PIECES OF FREEDOM

PIECES OF
FREEDOM

The Emancipation Sculptures of
Edmonia Lewis and Meta Warrick Fuller

Lee Ann Timreck Afterword by Alex Bostic

University Press of Mississippi / Jackson

Margaret Walker Alexander Series in African American Studies

The University Press of Mississippi is the scholarly publishing agency of the Mississippi Institutions of Higher Learning: Alcorn State University, Delta State University, Jackson State University, Mississippi State University, Mississippi University for Women, Mississippi Valley State University, University of Mississippi, and University of Southern Mississippi.

www.upress.state.ms.us

The University Press of Mississippi is a member of the Association of University Presses.

Library of Congress Cataloging-in-Publication Data

Names: Timreck, Lee Ann, author. | Bostic, Alex, writer of afterword.
Title: Pieces of freedom : the emancipation sculptures of Edmonia Lewis and Meta Warrick Fuller / Lee Ann Timreck, Alex Bostic.
Other titles: Margaret Walker Alexander series in African American studies.
Description: Jackson : University Press of Mississippi, 2023. | Series: Margaret Walker Alexander series in African American studies | Includes bibliographical references and index.
Identifiers: LCCN 2023006240 (print) | LCCN 2023006241 (ebook) | ISBN 9781496845870 (hardback) | ISBN 9781496845887 (trade paperback) | ISBN 9781496845894 (epub) | ISBN 9781496845900 (epub) | ISBN 9781496845917 (pdf) | ISBN 9781496845924 (pdf)
Subjects: LCSH: Fuller, Meta Warrick, 1877–1968—Criticism and interpretation. | Lewis, Edmonia—Criticism and interpretation. | Sculpture, American—19th century. | African Americans—Pictorial works. | Enslaved persons—Emancipation—United States. | Slavery in art. | United States—Race relations.
Classification: LCC N8243.S576 T56 2023 (print) | LCC N8243.S576 (ebook) | DDC 704.03/96073—dc23/eng/20230502
LC record available at https://lccn.loc.gov/2023006240
LC ebook record available at https://lccn.loc.gov/2023006241

British Library Cataloging-in-Publication Data available

CONTENTS

DEDICATION AND ACKNOWLEDGMENTS

Pieces of Freedom was inspired by the emancipation sculptures of Mary Edmonia Lewis and Meta Vaux Warrick Fuller and their brilliant visualization of the Black emancipation experience. To accurately capture their historical narrative, I relied on them to guide me throughout my research on post–Civil War and Reconstruction history, racism and gender discrimination, material culture, art history, and the shaping of historical memory. And to portray the economic, social, and racial conditions of post–Civil War Black life, I integrated the personal stories of those who lived it. This book, therefore, is dedicated not only to these two amazing women but also to the millions of newly emancipated African Americans who pursued their quest for freedom.

I am deeply grateful to the many experts who helped me along the way with support, resources, and sound advice, including Dr. Debra Lattanzi Shutika, George Mason University; Dr. Ryan Smith, Virginia Commonwealth University; Rachel Passannante of the Danforth Museum; the estate of Meta Warrick Fuller; and Stephanie Ward, my outstanding technical editor.

In closing, I want to express my heartfelt love and gratitude to my family—my husband, Nick, and my daughter, Sarah—for reviewing countless versions of this book and enduring my frequent disappearances down the book-writing rabbit hole. Together, we share not only a love for each other, but a love of history.

PIECES OF FREEDOM

INTRODUCTION

The end of slavery was the beginning of a new phase of conflict, which has now persisted for more than a century and a half, to the nation's lasting detriment and shame.
—Kirk Savage, *The Civil War in Art and Memory*

A picture is worth a thousand words. Whether the picture is a painting, a newspaper photograph, or a video, an image can trigger or create a narrative. On the anniversary of 9/11, when images of the smoldering World Trade Center flood the media, our personal stories of that day surge back. When we saw the larger-than-life image of George Floyd displayed upon the paint-and-graffiti-covered statue of General Robert E. Lee in Richmond, Virginia, many understood its message of racial injustice. And when nineteenth-century abolitionists published pictures of enslaved people, whipped and in chains, no caption was needed. Without a word, imagery has the power to connect, educate, and inspire the viewer.

"The emotional power of a historical image or of an individual or collective memory," writes historian David Blight, "is what renders it lasting."[1] And sculpture, the most enduring of the visual arts, is a powerful tool for shaping collective memories. After the Civil War, Southern whites recognized that the survival of their way of life depended on control of their historical narrative; they also understood the power of imagery. Within fifty years of the South's surrender at Appomattox, a new stone army of Confederate soldiers and generals had risen across the public landscape, each statue a visual manifestation of a white historical narrative known as the Lost Cause.[2]

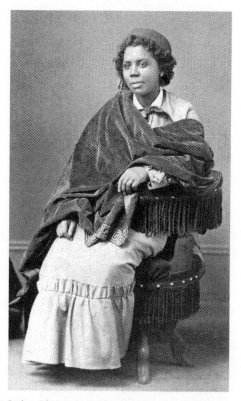

Figure I.1: Henry Rocher, *Edmonia Lewis*, photograph, ca. 1870. National Portrait Gallery, Smithsonian Institution, Washington, DC. NPG.94.95.

Was there no counternarrative, no alternative nineteenth-century imagery that depicted the Black experience? Was there no David, wielding chisel and hammer, to artistically challenge the handiwork of Goliath? Luckily, there were two. Mary Edmonia Lewis (1844–1909)[3] (figure I.1) and Meta Vaux Warrick Fuller (1877–1968) (figure I.2) were the only African American artists of the time to create sculptural representations of the Black emancipation experience. In 1867, Lewis completed her sculpture *Forever Free* in honor of the Emancipation Proclamation, and in 1913, Fuller unveiled her sculptural interpretation, *Emancipation*, for the fiftieth anniversary

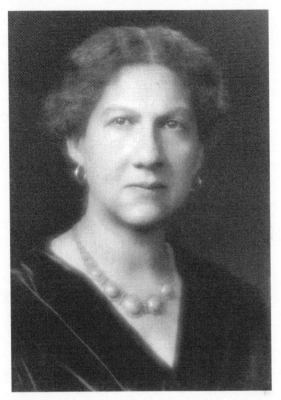

Figure I.2: Photograph of Meta Vaux Fuller. Courtesy of the Danforth Art Museum at Framingham State University.

of Black freedom.[4] Through the Black bodies of the newly emancipated, Lewis and Fuller rendered both an artistic visualization of the Black emancipation experience and a historical counternarrative to the Lost Cause. Not surprisingly, *Forever Free* and *Emancipation* achieved limited public exposure; over the same fifty-year period, some five hundred Confederate statues, monuments, and historical markers would ascend across the nation.

Lewis and Fuller lived through an era that unleashed some of the most transformative and sorrowful events in American history: the freeing of four million African Americans, the passage of the

Thirteenth and Fourteenth Amendments to the US Constitution, Reconstruction, Jim Crow, and segregation. The danger of ignoring this history, as historian Carter Woodson points out, is that "if a race has no history, if it has no worthwhile tradition, it becomes a negligible factor in the thought of the world, and it stands in danger of being exterminated."[5] Lewis's and Fuller's personal experiences as Black female artists shaped their visual narrative, and their insight into the lives of a newly emancipated people shaped their historical narrative. Although relatively unknown, Lewis's and Fuller's emancipation sculptures are valued as pieces of fine art and unique historical artifacts of the Black emancipation experience.

Contemporary historians and authors, such as Edward Ayres, David Blight, Ta-Nehisi Coates, Mary Farmer-Kaiser, Eric Foner, Ibram X. Kendi, Kirk Savage, and Leslie A. Schwalm, to name a few, have produced fresh, comprehensive scholarship to correct the historical record on emancipation and the legacy of Reconstruction. Their work reexamines the social, political, and economic events of this history and how these actions embedded racial inequality and injustice into all aspects of the American landscape. Additionally, art historian Kirsten Buick's book *Child of the Fire: Mary Edmonia Lewis and the Problem of Art History's Black and Indian Subject* and art historian Renée Ater's book *Remaking Race and History: The Sculpture of Meta Warrick Fuller* provide wide-ranging and thorough scholarship on the lives, careers, and artistic accomplishments of these two exceptional women.

Historians Claire Parfait, Hélène Le Dantec-Lowry, and Claire Bourhis-Mariotti write that "material and visual cultures are a convincing tool to unearth and define the life of African Americans, . . . [to] understand how people in relatively powerless positions were able to make a place for themselves and their community in, mostly, 'unwritten history.'"[6] Today, these unwritten pieces of history—oral histories, traditions, celebrations, art, and vernacular

objects—are recognized as historical artifacts and primary sources for historical research. Thus, this book argues that material culture, and specifically the sculptures *Forever Free* and *Emancipation*, are important nineteenth-century historical artifacts. By examining the history of emancipation through the art of nineteenth- and early twentieth-century Black artists, and specifically Edmonia Lewis and Meta Warrick Fuller, a more comprehensive and gendered historical narrative of the Black emancipation experience emerges.

In 2020, in response to the killing of George Floyd, thousands of Americans took to the streets demanding reforms to address racial discrimination and injustice, putting our competing versions of history on public display. Banners painted with "Black Lives Matter" came face-to-face with Confederate flags. The continuous media stream of misinformation and "alternative facts" only made us more skeptical of what we saw and heard. As a result, many Americans simply doubled down on what they already believed. Why, then, should we consider Lewis's and Fuller's narratives of the Black emancipation experience as historical truth, and, more importantly, what can we learn from their sculptures that has any bearing on twenty-first-century America?

Art is often created to communicate social consciousness and political viewpoints. In explaining the unique social impact of sculpture, the civil rights activist and author Freeman Henry Morris Murray writes that "sculpture more frequently than painting serves higher purposes than that of mere ornament or of the mere picturing of something. Often it is designed to commemorate some individual or some event, or, particularly in the group form, its main purpose is to 'say something.'"7

Lewis and Fuller were acutely aware of the ideological function of art and its ability to "say something." They used their art to create realistic images of their Black subjects, in sharp contrast to the racist caricatures of Black physicality and intellect made popular in nineteenth-century art and literature. Fuller's mindfulness to accurately depict her Black figures is reflected in a letter she

wrote to her friend Freeman Murray in 1915. She mentions that her husband did not like the "swing in the legs" of the Black male in her *Emancipation* sculpture, but she disagreed with him: "I had associated the pose of the knees with lithe, youthful Negroes. . . . I do not think that there is the slightest trace of caricature."[8]

Lewis and Fuller knew the importance of not only the physical depiction of their Black subjects but the accurate representation of the political, social, and economic life of nineteenth-century Black Americans. Thus, every aspect of their sculptures is purposeful—facial expressions, posture, positioning of subjects, clothing, racial and gender tropes—to communicate a meaningful and relevant narrative of the emancipation experience to their audiences. Lewis's success is summarized in Elizabeth Palmer Peabody's 1869 review of *Forever Free*. Peabody notes, "No one, not born subject to the 'Cotton King,' could look upon this piece of sculpture without profound emotion[,] . . . telling in the very poetry of stone the story of the last ten years."[9]

But how to accurately interpret the artist's intended artistic message without an explicit description from the artist herself? In her scholarship on Edmonia Lewis, art historian Kirsten Buick describes her approach to analyzing Lewis's art: "My purpose is to pose cultural contextualization rather than racial tautology as the means for exploring Lewis's work. Lewis's acts of agency—her art—can provide a perspective from which to view the various communities in which she took part. . . . She is central to the compelling issues of ethnicity, gender, and nation."[10] Therefore, we cannot interpret Lewis's or Fuller's sculpture in isolation, or through a twenty-first-century lens, but rather must analyze it within the context of nineteenth-century history and culture.

Historian and author Peter Gay, in his work on causal analysis of art, provides an approach for determining artistic intent by examining the influences on each artist at the time the art was created. Gay identifies three categories of influences—*craft*, *culture*, and *privacy*—that together form a "causal tapestry" of influence on the

individual artist and her work.[11] In the case of nineteenth-century art, for example, if we understand the *craft* of neoclassical art and its restrictions on Black subjects, as well as the gendered expectations of the nineteenth-century *culture* of "true womanhood," we better understand Lewis's struggle to represent Black women in fine art.[12] And if we are aware that Fuller's use of nudity conflicted not only with the accepted Black iconography of her *craft* but also with Black middle-class *culture*, which considered Black nudity in art as reinforcing racial stereotypes of Black people, then we appreciate her artistic courage. And for each woman, her *private* beliefs on issues such as racism, injustice, and women's rights also played a key role in shaping her artistic narrative. Thus, to mitigate twenty-first-century biases and misinterpretations, this book examines Lewis's and Fuller's emancipation sculptures within the context of their individual causal tapestries.

At the beginning of the twentieth century, historian and civil rights advocate W. E. B. Du Bois, despairing over fifty years of broken white promises and wounded Black souls, wrote that "the freedman has not yet found in freedom his promised land. Whatever of good may have come in these years of change, the shadow of deep disappointment rests upon the Negro people."[13] But Du Bois also was hopeful; he knew that, during those same fifty years, African Americans had created a rich and vibrant history of Black accomplishments, Black communities, and Black lives. The emancipation sculptures of Lewis and Fuller—and their visual narratives of a people's strength and humanity in the face of oppression—embody this hope. Their art not only depicts America's history of racism but also celebrates the stories of Black uplift and empowerment by a newly emancipated people.

David Blight reminds us that "in scholarship and especially in the realm of public history, we cannot let our society take a holiday from understanding the deep imprint slavery, the Civil War, Reconstruction, and the era of lynching and Jim Crow left on generations of Americans."[14] This, then, is my request to the

reader: first, view the sculptures of Edmonia Lewis and Meta Warrick Fuller as historical artifacts capable of contributing to the historical record on nineteenth-century Black life; second, engage fully with Lewis's and Fuller's visual narrative to better understand the history of Black freedom; and finally, respect the lives of four million newly emancipated people and their history.

The history of Black freedom is replete with the struggles of African Americans for political representation, civil rights, and economic freedom—the promises made by President Abraham Lincoln when he signed the Emancipation Proclamation in 1863. The importance of learning this history *today* is summarized in a news release about the recently published Zinn Education Project report *Erasing the Black Freedom Struggle: How State Standards Fail to Teach the Truth About Reconstruction*: "Teaching and learning the truth about Reconstruction is not only about correcting or supporting the historical record. . . . It is about understanding why disparities in wealth, education, health, and policing exist, the ways they are maintained, and the power of collective action in overturning them and creating a better world."[15] Over the next four chapters, this book explores this critical history through the emancipation sculptures of Edmonia Lewis and Meta Warrick Fuller.

Chapter 1, "Women of Mark," introduces the reader to the lives and art of Edmonia Lewis and Meta Warrick Fuller, and specifically their emancipation sculptures *Forever Free* and *Emancipation*. As highly accomplished African American "women of mark," Lewis and Fuller not only broke racial barriers through their realistic and dignified depiction of their Black subjects; they also crafted a rare and powerful visual narrative of emancipation from the Black perspective. Although similar in theme, the two emancipation sculptures were sculpted fifty years apart and differ greatly in artistic style, emotion, and narrative. To understand the differences between the artists' depictions of the Black emancipation experience, this chapter explores how the elements of *craft*, *culture*, and *privacy* influenced each artist and shaped their art.

After the Civil War, the exuberance of the newly emancipated—the joy of being free, legally marrying, reuniting with family, and starting new ones—was soon tempered by the economic and racial realities of the post–Civil War South. Chapter 2, titled ". . . thenceforward, and forever free," discusses the nation's failure to deliver on the promises of emancipation, the rise of Jim Crow and segregation, and their impact on the lives of the newly freed. Presenting this painful history through the stories and voices of nineteenth-century African Americans deepens our understanding of the world they lived in and how this shaped Lewis's and Fuller's sculptural vision.

Lewis and Fuller used their art as a platform against racial and gendered injustice, both through their imagery and their narrative. Thus, chapter 3, "Lifting as They Climb," focuses on Lewis's and Fuller's personal experiences as Black women and the constraints of the nineteenth-century "cult of true womanhood," the challenges they faced in depicting Black womanhood in art, and the importance of their gendered visualization of the Black emancipation experience.[16] By contextualizing the imagery and narrative of each artist's emancipation sculpture through the lens of nineteenth-century gender and race discrimination, the reader gains a broader historical understanding of the sacrifices and accomplishments made by Black women after emancipation.

Over time, as historical racism permeated our educational institutions and curricula, the Black history of emancipation, Reconstruction, and Jim Crow became nearly invisible to the American public. In the words of author and historian Ibram X. Kendi, "Until midcentury, the Dunning School's fables of slavery and Reconstruction were transferred into schoolbooks, or at least into those that mentioned Black people at all."[17] Accordingly, chapter 4, "Never Forget," argues that the lesser-known historical narrative of the Black emancipation experience—replete with the personal stories and lived experiences of African Americans—must become part of our national consciousness. Power and

access are keys to the creation of historical memory, and white power enabled a fictitious national memory of the Civil War and Reconstruction that we struggle to correct to this day. Thus, this chapter explores the importance of correcting the historical record and what Lewis's and Fuller's sculptural legacies teach us about the history of Black freedom.

◆ ◆ ◆

America's national identity was shaped by historical beliefs about white exceptionalism and who qualifies as an American. Frederick Douglass, W. E. B. Du Bois, and Martin Luther King Jr. all dreamed of a new interracial American identity, but it was not to be in their lifetimes. To fulfill this dream, white Americans must be willing to change tightly-held historical beliefs that ignore our racist past. And as Americans engage truthfully with this nation's history, they also begin redefining our national identity.

The sculptures of Edmonia Lewis and Meta Warrick Fuller, and their powerful imagery of the Black emancipation experience, can assist. "An understanding of the relevance, meaning, and definition of historical American art," writes the scholar and educator Tiffany Washington, "is key to a redefinition of America, its democracy and what both have to do with our culture."[18] By examining the historical narrative of Lewis's *Forever Free* and Fuller's *Emancipation*, we can explore this critical connection between our past and our present. Through their art, we see a newly emancipated people clad in dignity and hope; through their narrative, we hear the stories of challenges and accomplishments despite the cruelty of racial discrimination. This history shaped the America we live in today, and any effort to redefine our national identity must begin here.

WOMEN OF MARK

We have heard and read much of men of mark of our race, but comparatively little is known of able Afro-American women.

–Susan Elizabeth Frazier (1892)

Edmonia Lewis and Meta Warrick Fuller were serious and accomplished women but not without a sense of humor. They were the first two female African American sculptors, so it is not surprising that people might confuse one with the other despite their thirty-three-year age difference. In a 1915 letter to activist and author Freeman Murray, Fuller recounts a personal story of misidentification by a gentleman while she was doing some library research, writing, "[He] did me the honor of mistaking me for Edmonia Lewis until I enlightened him. . . . He must have supposed E[dmonia] had discovered the fountain of perpetual youth for she was certainly well-known before I was even born."[1] So as we explore the accomplishments of these two remarkable women, specifically their visual narrative of the Black emancipation experience, let us also remember them as real flesh-and-blood women who lived, loved, and laughed.

◆ ◆ ◆

In 1892, the African American educator and social activist Susan Elizabeth Frazier penned an essay titled "Some African American

Women of Mark," highlighting the accomplished Black women who, "self-prompted, and in some cases self-taught, have removed obstacles, lived down oppression and fought their way nobly on to achieve the accomplishment of their aim."[2] One of these "women of mark" was Edmonia Lewis, described by Frazier as "the greatest of her race in the art of sculpture."[3] Sixty-four years later, cultural historian Margaret Butcher would write that Meta Warrick Fuller's skills were second only to the artist Henry O. Tanner as "the greatest vindicating examples of the American Negro's conquest of fine arts."[4]

Why such high praise for these two women? Not only were they highly skilled artists, they were the first Black female sculptors to tackle the controversial themes of race, gender, and social injustice through fine art. In an art world dominated by white men, these two women broke racial barriers to render realistic Blackness in their work, creating some of the earliest representations of Black bodies in sculpture. But it is not just their artistic legacies that define them as "women of mark"; it is also what their work tells us about the social and racial realities of Black life in nineteenth- and early twentieth-century America.

Although Edmonia Lewis was born in 1844 and Meta Warrick Fuller in 1877, the two women were more alike than different. Both were freeborn, well educated, artistically trained and, as such, were members of the Black middle class. Both were challenged by ideological constraints that considered fine art and sculpture exclusively a white domain, and they both struggled to work within the nineteenth-century "cult of true womanhood," a socially pre-scribed set of behaviors and attitudes all women were expected to adhere to.[5] And as Black women, they both experienced racial discrimination throughout their personal and professional lives. Yet despite these similarities, their emancipation sculptures differ greatly in artistic style, emotion, and thematic presentation. Why? First, in the fifty years that separated these two sculptures, American art evolved from neoclassical realism to a more "modern" abstract

style, a difference reflected in each artist's aesthetic choices. Second, this same fifty-year period is a history of failed promises to the newly freed. Thus, Lewis's *Forever Free*, sculpted in the neoclassical style between 1865 and 1867, faithfully depicts the joyous response to the news of freedom as well as a hopeful message of Black agency.[6] In 1913, Fuller renders a somber *Emancipation* sculpture in the beaux arts style, depicting an emotional narrative of sacrifice and determination in the face of racial oppression.

Forever Free and *Emancipation* are both fine art and historical artifacts—pieces of freedom, if you will—that we can study for what they tell us about the history of the Black emancipation experience. But if the sculptures *look* different, are their historical narratives different? If so, how are they different? Art historian Charmaine Nelson explains that although sculpture is worthy of historical scrutiny, "any such inquiries must be attentive to the vast differences in identity and subjectivity of the artists, which in every way mediated their vision, mobility, access, production and experience."[7] In other words, to understand the differences between Lewis's and Fuller's depictions of the Black emancipation experience, we must examine their art in the context of the artistic, gendered, and racial influences on each artist *at the time* they created their emancipation art.

◆ ◆ ◆

Although recognized today as highly skilled and accomplished artists, throughout their lives both Lewis and Fuller were seen first and foremost as Black women. Despite Edmonia Lewis being this country's first female African American sculptor and successfully establishing an international artistic career, an 1871 newspaper article in the *Morning Republican* typifies how Lewis was perceived: "Edmonia Lewis is below the medium height: her complexion and features betray her African origin; her hair is more the black of the Indian type, black, straight, and abundant.

She wears a red cap in her studio, which is very picturesque and effective; her face is a bright, intelligent and expressive one. Her manners are childlike, simple, and most winning and pleasing."[8] Yet Lewis, who by the age of twenty had successfully set up her own sculpture studio and established herself as a working artist, was hardly "childlike" or "simple." By any measure, she was a passionate artist who overcame great odds to succeed. While the lack of written documentation on Lewis's personal life creates a somewhat mysterious persona, her artistic accomplishments speak loudly of a talented and intelligent artist.

Lewis was born in upstate New York in 1844 to an African American father and a Chippewa (or Ojibwa) mother. Orphaned by the age of nine, Edmonia and her older brother, Samuel, were adopted by their mother's sister. For the next four years, Lewis—or Wildfire, her Native American name—lived in the Buffalo, New York, area with her Chippewa relatives. In an 1866 interview with Henry Wreford for *The Athenaeum*, she is quoted as saying: "Mother often left her home, and wandered with her people . . . and thus we her children were brought up in the same wild manner. Until I was twelve years old I led this wandering life, fishing and swimming, and making moccasins."[9]

While her early years reflect a nomadic existence with her Chippewa relatives, Lewis soon transitioned to a different lifestyle. In an interview for the *Portland Transcript* in 1866, she explains: "When I was about thirteen years of age, my brother [Samuel], who was much older than me, sent word that he wished that I should be educated. He sent money for the purpose."[10] She attended a Baptist abolitionist school for three years and, in 1859, entered Oberlin College in Ohio. Lewis's experience at Oberlin was marred by race-based violence, as art historian Kirsten Buick explains:

> In 1862, while a student at Oberlin, Lewis was accused of poisoning her two white roommates, a serious charge of which she was ultimately found innocent. While awaiting trial at Oberlin,

Lewis was severely beaten by unknown assailants, exposing her to racism despite the school's advanced attitude towards equality in education.[11]

Lewis left Oberlin in 1864 and moved to Boston to pursue her career as a sculptor. In Boston, Lewis soon connected with the abolitionist community, including well-known activists such as William Lloyd Garrison, Lydia Maria Child, and Elizabeth Palmer Peabody. All were eager to support a talented African American artist, and their mentoring played a critical role in her success. They not only funded Lewis's early career but also introduced her to the sculptor Edward Brackett, who accepted her as his student. More importantly, these influential abolitionists publicized Lewis's work in the abolitionist press and advanced her reputation.

By 1865, Lewis completed her formal training in sculpture, successfully sold her first pieces of art (which included sculptures of abolitionist leaders John Brown and William Lloyd Garrison), and moved to Rome to set up her own art studio. Buick explains Lewis's decision to pursue an expatriate life: "Rome represented to Lewis an escape from the constraints of race and sex, an escape from American prejudice, and an opportunity that few women (especially women of color) could enjoy."[12] In Rome, Lewis joined an expatriate colony of American female artists that included Harriet Hosmer, Charlotte Cushman, and Anne Whitney. She would live and work in Rome the rest of her life, achieving fame both at home and abroad for her art; clients and visitors flocked to her art studio throughout the 1870s and 1880s. But as the nineteenth century ended, and public interest in neoclassical art diminished, Lewis faded from the public eye and disappeared completely after her death in 1909.

Early in her career, Edmonia Lewis sculpted the emancipation statue *Forever Free* (1865–1867) (figure 1.1). Inspired by the Emancipation Proclamation and sculpted in the neoclassical style, Lewis's white marble imagery evokes the glorious first

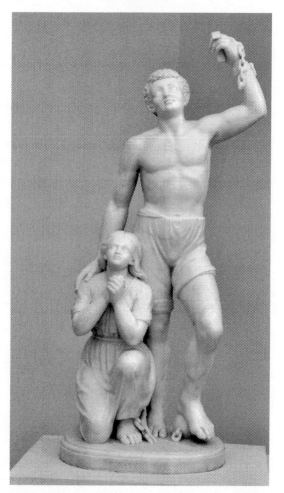

Figure 1.1: Edmonia Lewis, *Forever Free*, 1867. Howard University Gallery of Art, Washington, DC.

moments of freedom for two newly emancipated people. Although still wearing the worn garments of the enslaved, Lewis's freedman stands triumphantly, head raised skyward and shackled arm lifted, and his other hand rests protectively on the shoulder of the kneeling freedwoman beside him. We see a chained ankle exposed from under the freedwoman's rough dress, yet her hands are clasped

in pious gratitude, and she looks joyfully to the heavens. When *Forever Free* was unveiled in Boston in 1869, the work was effusively described by the abolitionist Elizabeth Palmer Peabody in the *Christian Register*:

> All who were present at Tremont Temple on the Monday evening of the presentation to Rev. Mr. Grimes of the marble group "Forever Free" by Miss Edmonia Lewis must have been deeply interested. No one, not born subject to the "Cotton King," could look upon this piece of sculpture without profound emotion. The noble figure of the man, his very muscles seeming to swell with gratitude; the expression of the right now to protect, with which he throws his arm around his kneeling wife.[13]

Lewis's *Forever Free* is more than a historical narrative of Black freedom; it is also a visual expression of the new reconstructed Black family and how it conformed with nineteenth-century gender ideals.[14] Thus, Lewis's hierarchical positioning of her two subjects reflects the freedman's new status as head of household and the freedwoman's deferential role as wife and mother.

◆ ◆ ◆

At the turn of the twentieth century, the African American sculptor Meta Warrick Fuller would burst onto the fine art scene. She was born in 1877 to William and Emma Warrick, both successful business owners and members of Philadelphia's Black elite. It was Meta's father who inspired her love of the arts, taking her frequently to the Philadelphia Academy of Fine Arts and to theatrical events at the nearby Walnut Street Theatre and the Academy of Music.[15] The Warrick family enjoyed a privileged life; Meta and her siblings participated in numerous social activities with friends and family, including musical, theatrical, and literary events, and escaped to Atlantic City during the hot Philadelphia summers.

By the age of twelve, Meta was pursuing her artistic and musical aspirations in Philadelphia. She first attended the Industrial Art School, then the Girl's High Normal School, followed by a postsecondary education at the Pennsylvania Museum School of the Industrial Arts. All these educational institutions were highly selective and accepted very few Black students. Meta's acceptance reflects her artistic gift and the excellence of her work. By the time she graduated from the Pennsylvania Museum School in 1899, she had demonstrated an exceptional talent across a range of disciplines, most notably sculpture, and won a number of prestigious awards.[16] That same year she went on to study in Paris, where her talent and hard work earned her the opportunity to display her art in some of Paris's finest galleries. Meta returned to Philadelphia in 1902 to a celebrity welcome, as written in the *Philadelphia Tribune*: "Black Philadelphians welcomed the news that she was going to open a studio in their city and echoed a Parisian critic's appraisal that if she worked long enough, Meta would prove to have not only talent but genius."[17]

Despite her accomplishments in Paris, the warm welcome Meta enjoyed from the Black community of Philadelphia did not translate into acceptance by the white art world. After numerous unsuccessful attempts to sell her work, she worried that racism and sexism would prevent her from ever making a living in her chosen profession. However, her luck turned in 1906 when she was awarded a commission to create a historical piece of art for the 1907 Jamestown Tercentennial Exposition. It was the first commission ever awarded by the US government to an African American woman, and it provided Meta a highly visible showcase for her work. For the exposition, she created a tableau titled *Landing of First Twenty Slaves at Jamestown*, which included fourteen dioramas depicting three hundred years of African American history.[18] Although the exposition committee awarded her a gold medal in the fine art category, Meta's personal experience at the exposition left a bitter aftertaste. Art historian Judith Kerr writes:

When she had discharged her responsibilities at the Negro Building, Meta had wanted to visit the exposition like any other tourist. Years later, she could still remember her disbelief when she "set out to the different exhibits" and discovered that she "couldn't have anything to eat anywhere" at the fair. "I had gotten a Gold Medal for that exhibit, (I didn't know at the time), but I couldn't eat at any of the eating places," she said. . . . Being turned away at the Exposition's soda fountains and restaurants humiliated Meta.[19]

In 1909, Meta Vaux Warrick married Solomon Carter Fuller Jr., a neurologist and the first African American psychiatrist.[20] They moved to Framingham, Massachusetts, and Solomon established his medical research and teaching career in Boston. Meta reluctantly settled into her new domestic role, worried about the constraints that married life would put on her artistic aspirations. In a letter to Freeman Murray, she writes: "Oh, for the days of 'cooperative housekeeping' or 'progressive housekeeping.' . . . Anything to give us food and raiment and cleanliness without the drudgery that takes us away from the work we love."[21] Her husband disapproved of her professional pursuit of sculpture, expecting his wife to focus on taking care of the household, raising their children, and meeting social obligations.[22] Fuller would struggle with this tension between domestic expectations and her artistic career throughout her life, often wondering "what if" she had stayed in Paris and devoted herself to art. Despite these challenges, Fuller successfully built a body of work that included not only sculpture and paintings but also theatrical sets, costume designs, and original plays. When she passed away in 1968, she left behind a legacy now recognized for its artistic brilliance and passion, which art historian David Artis calls a "celebration of African heritage, employment of the tradition of black folklore, [and] respectful treatment of everyday black life."[23]

For the fiftieth-anniversary celebration of the Emancipation Proclamation, Du Bois commissioned Fuller to create a monument

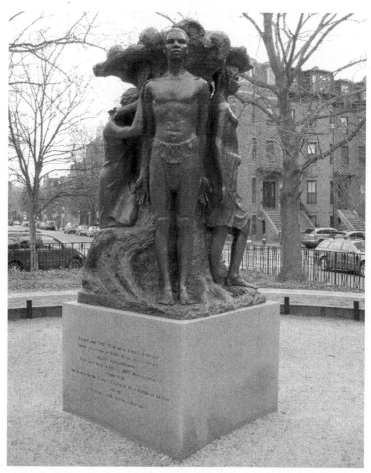

Figure 1.2: Meta Fuller, *Emancipation*, produced in plaster, 1913; bronze, 2000, located in Harriet Tubman Square in Boston's South End, Massachusetts. Courtesy of the Danforth Art Museum at Framingham State University.

to the African American emancipation struggle. Fuller eagerly accepted the challenge, and the result was her groundbreaking sculpture titled *Emancipation* (figure 1.2). In contrast to Lewis's emancipation sculpture *Forever Free*, there are no chains or kneeling slaves; rather, Fuller expresses her visual narrative of

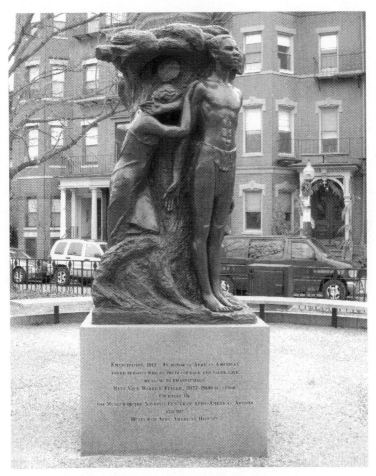

Figure 1.3: Meta Fuller, *Emancipation*, 1913; detail of the allegorical figure Humanity.
Courtesy of the Danforth Art Museum at Framingham State University.

emancipation through the physicality of her subjects, the inclusion of allegorical imagery, and subtle expressions of racial injustice.

In *Emancipation*, the two newly emancipated African Americans, with distinctly African facial features, stand side by side and seemingly poised for flight. They wear only the roughest of

clothing around their waists; the freedman's masculinity evidenced by the rippling muscles across his chest, and the freedwoman's sexuality and vulnerability displayed through her bare breasts. Standing behind the two freedom travelers is the allegorical figure of Humanity (figure 1.3). She leans heavily on the freedman's shoulder, one arm supporting her bowed head, as if unable to bear the pain and suffering she knows the newly emancipated will encounter on their journey.[24] Fuller herself explains to Freeman Murray that "Humanity is weeping over her suddenly freed children, who, beneath the gnarled fingers of Fate, step forth into the world, unafraid."[25] Fuller's artistic interpretation of emancipation seemed to have struck an empathetic chord with her audience, as evidenced in a review by the *Framingham Evening News*: "In the attitude of the two figures, who start out empty-handed to try the new life, is strikingly expressed the state of mind which must be theirs; eagerness, uncertainty, timidity, and courage; trying to realize all that freedom means and hesitating before taking the plunge."[26]

◆ ◆ ◆

Forever Free and *Emancipation* differ greatly in artistic style and composition, yet both convey an emotional and historical narrative of the Black emancipation experience. To decipher the differences between Lewis's and Fuller's artistic representations of emancipation, and what their sculptures tell us about the first fifty years of Black freedom, we must examine how each artist's "causal tapestry"—the integrated elements of *craft, culture,* and *privacy*—shaped her art.[27]

Lewis and Fuller both worked within the white, male-dominated *craft* of fine art. Lewis worked within the neoclassical genre, an aesthetic that recognized "ideal beauty" as white only; Black bodies or Black themes were practically nonexistent. Describing nineteenth-century sculpture, historian Kirk Savage notes that "classical sculpture still served as the benchmark of the sculptural

and thereby defined what was not sculpture—most fundamentally, the body of the 'Negro.'"[28] Faced with this artistic conundrum of white idealism and Black realism, art historian Charmaine Nelson suggests that Lewis struggled to achieve an artistic compromise between "acceptable neoclassical iconography and authentic physicality of Black bodies."[29]

This conflict on how to represent Black bodies in fine art was not limited to Lewis. For example, Anne Whitney, a nineteenth-century white female sculptor, met with strong criticism of her sculptural attempts to combine Africanized features with idealized neoclassical expectations in her Black female subjects. Art historian Melissa Dabakis writes: "Like others before her, she [Whitney] worked within the limited vocabulary of neoclassicism and produced a sculptural vision that mediated between the formal qualities derived from African features and those of classical (white) beauty."[30]

This artistic struggle is most noticeable in Lewis's freedwoman, whose delicate, mixed-race facial features contrast with her thicker, less refined physical characteristics. This aesthetic met with mixed reviews. Writing to a friend in 1866 about an earlier version of the sculpture, Lydia Maria Child (one of Lewis's abolitionist sponsors) observes that "the face [of the freedwoman] is pretty good, but the figure is shockingly disproportioned. The feet are monstrous."[31] Dabakis suggests that "Lewis may have tried to redefine proper femininity in terms that would embody the tenets of freedom and make visually evident a new identity for the black female."[32] While we do not have Lewis's own words to validate her intent, there is no question that *Forever Free* is an unprecedented piece of nineteenth-century neoclassical art that represents both the physicality and the spirit of newly-freed Black men and women.

Fuller's *Emancipation* sculpture, with its rough, bronzed finish, is a strong contrast to Lewis's more delicate white marble work. By the late nineteenth century, fine art was evolving away from the neoclassical style to a revival of the Renaissance and baroque

styles, described by art historian Sharon Patton as "dark bronze with textured surfaces, naturalism in the forms, and showing forms in movement."[33] For Fuller, the challenge posed by her *craft* was how to both dignify the history of a formerly enslaved people and still convey a racially uplifting narrative of nineteenth-century Black accomplishments. Many Black middle-class citizens worried that Black nudity in art, no matter how skillfully rendered, was counterproductive to their efforts to refute the racist stereotypes that existed throughout American society. These African Americans wanted to see "images of black people cloaked in the politics of respectability," writes historian and author Henry Louis Gates Jr., in order to prove that "they embodied the same middle-class social and moral Victorian values and aspirations that the white middle class did, and were therefore deserving of equal treatment in every way."[34] But Fuller was willing to risk viewer discomfort to tell the evolving narrative of enslavement, freedom, injustice, and progress. Using the stripped-down bodies of the newly emancipated to narrate the history of Black freedom, she challenged what historian W. Fitzhugh Brundage called "the exclusive authority of white Americans to represent and signify, to embody, either the nation or civilization."[35]

Lewis and Fuller were also influenced by the nineteenth-century gendered *culture* known as the "cult of true womanhood," or "cult of domesticity," which expected women to adhere to an exhaustive set of socially accepted behaviors and activities.[36] In *Forever Free*, Lewis used the hierarchical positioning of her subjects and conventional symbols to acknowledge these gender-based *cultural* demands. Thus, Lewis's freedman stands with a raised fist, reflecting his manhood and role as head of household, while the kneeling freedwoman exudes the qualities of piety, domesticity, and dependence expected of nineteenth-century women.

Abolitionists argued that slavery had destroyed the Black family unit and that the reconstitution of the Black family—and the Black woman's attainment of true womanhood—should be a priority

after emancipation. But for millions of newly emancipated Black women, this was a vicious circle; forced to work, they had no time, energy, or money to demonstrate the social norms of "true womanhood," yet their inability to meet these standards rendered them "uncivilized" in the eyes of nineteenth-century white Americans. As author Paula Giddings explains: "The Black woman's obligation to perform double duty in both home and field had dissipated her role as wife and mother and symbolized the low esteem in which she was held in society."[37] Although gendered prohibitions for women relaxed slightly by the beginning of the twentieth century, married women were still expected to prioritize their role as wife and mother. As women challenged gender stereotypes and structures, historian Barbara Welter points out, "the stereotype, the 'mystique' if you will, of what woman was and ought to be persisted, bringing guilt and confusion in the midst of opportunity."[38]

Fuller chafed in this *cultural* vise, continuously juggling her domestic responsibilities with her artistic career, and her perspective on gender inequalities, and specifically for Black women, figures prominently in her art. In Fuller's *Emancipation*, the elevation of the freedwoman alongside the freedman is noticeably different from the hierarchical positioning in Lewis's *Forever Free*. In describing Fuller's earlier award-winning work for the 1907 Jamestown Tercentennial Exposition, historian W. Fitzhugh Brundage notes, "[Fuller] avoided a male-centered historical narrative. Her dioramas presented the black past as a saga of male and female survival and accomplishment."[39] Thus, the positioning and expressions of her two subjects in *Emancipation* likely convey a similar narrative of shared progress between Black men and women throughout their journey to freedom.

The third element of each artist's "causal tapestry"—*privacy*—is one which Peter Gay defines as "man's most intimate worlds, those of his family and his inner life."[40] *Private* feelings are often expressed in journals, letters, and diaries; in Lewis's case, the few written

documents that exist illuminate her strongly held beliefs on race and social injustice. In a letter Lewis wrote in 1867 to one of her Boston-based patrons, Lydia Chapman, she expresses her feelings about *Forever Free* and her desire to dedicate it to the famous abolitionist William Garrison: "I will not take anything [in payment] for my labor. Mr. Garrison has given his whole life for my father's people, and I think that I might give him a few months' work."[41]

Throughout her life, Lewis was portrayed as a Black or Native American woman first and an artist second; as a result, her art is often defined through that lens. But Lewis refused to be characterized as a race artist or seek special treatment because of her gender. In an interview in 1864, Lewis says to Lydia Maria Child, "Some praise me because I am a colored girl, and I don't want that kind of praise."[42] Lewis also worried about questions of her artistic legitimacy, aware that many doubted the ability of an African American woman to sculpt artistic masterpieces. To counter even the slightest doubt of authenticity, Lewis adopted an unusual sculpting process, as described in the *Morning Republican*: "Miss Lewis is one of the few sculptors whom no one charges with having assistance in her work. . . . So determined is she to avoid all occasion for detraction, that she even 'puts up' her clay; a work purely mechanical, and one of great drudgery, which scarcely any male sculptor does for himself."[43]

Fuller's *private* feelings about her family and her art surface in her letters to Freeman Murray.[44] Although she privately struggled with the gendered restrictions on her artistic career, she was devoted to her children, and in one letter she lovingly writes: "I have promised them some music as soon as my letter is finished so I must end and now for romp and 'watch for Daddy' supper, another romp—perhaps a little dancing then off to bed—two sleepy little tots brim full of life and mischief."[45] Yet, she was passionate about using her art to depict the suffering and injustice heaped upon her race, and she tackled the themes of self-determination and agency throughout her life. Again, Fuller reveals her thoughts

in a letter to Freeman Murray: "I wanted to try my hand at a short play or a story built around some phase of the race issue but I suppose after all it is foolish but I am all afire to <u>do</u> something."[46]

When the influences of *craft, culture,* and *privacy* on an artist are identified, analyzed, and integrated, they provide a roadmap for interpreting each artist's narrative intent. And while each "causal tapestry" is unique to each artist, similarities can exist. In the case of Lewis and Fuller, both worked in a white man's craft that devalued them, and both lived in a white culture that disregarded them; and yet, they were suffused with an indomitable spirit to "do something." Today, their art is seen as nothing less than ground-breaking. Lewis's *Forever Free* not only pushes the traditional boundaries of neoclassical beauty through its inclusion of Black bodies, it also communicates her political and social perspective on the new free identity of newly emancipated men and women. In *Emancipation,* Fuller uses the physicality and realism of her two Black freedom travelers to express the agency of a newly freed people—stripped naked by enslavement, battered by racism, but ever moving forward.

◆ ◆ ◆

Two women, two sculptures, two emancipation narratives. In some ways the same, in some ways different, but together, they provide a rare first-person narrative of the first fifty years of Black freedom. Just as *Forever Free* and *Emancipation* are more than images of Black bodies sculpted by Black artists, so Lewis and Fuller are more than talented African American sculptors. Through their *craft,* Lewis and Fuller artistically counter the grotesque depictions of Black Americans with imagery of a dignified and self-determined people; through their Black subjects, they express the political and social realities of nineteenth-century *culture*; and shaped by their *private* and personal experiences, they convey a racial and gendered visualization of the Black emancipation experience.

At the 1900 Paris International Exhibit, Du Bois received a gold medal for his "American Negro" photographic display, which "charted African American advancement and monochromatic photographs that presented Black lives, in labor, worship, and leisure, at school, at work, and at home."[47] In describing the exhibit, photograph historian Deborah Willis observes that "these photographs explore a corrective visual history as they are read as images of self-empowerment, self-determination, and self-recovery."[48] Her words apply as well to the legacy of Lewis's and Fuller's emancipation sculptures. By capturing in stone the visual history of the newly emancipated as they walked that road to freedom, Lewis and Fuller have bequeathed us a lasting picture of Black courage and determination.

"...THENCEFORWARD, AND FOREVER FREE"

Or shall we hang our heads in shame?
Stand back of new-come foreign hordes,
And fear our heritage to claim?
No! stand erect and without fear,
And for our foes let this suffice–
We've bought a rightful sonship here,
And we have more than paid the price.
–James Weldon Johnson

With a stroke of his pen, Lincoln rendered enslaved African Americans "forever free"—but would the toll of racism drive the cost of freedom beyond their grasp?[1] From the earliest days of slavery, African Americans sought freedom in every way they could and paid dearly for it. The cost of resistance included whipping, disfiguration, rape, starvation, and death. And yet, again and again, they resisted. Many fought back or ran away, others intentionally sabotaged plantation crops and equipment, and Black families defiantly upheld the customs and traditions of their African heritage. With the outbreak of the Civil War, the price of liberty went up again; between four and five hundred thousand slaves ran away to serve as Union "contrabands of war"

in exchange for their freedom, and in 1862, when President Lincoln authorized military service for African Americans, nearly two hundred thousand Black men volunteered.[2]

In April 1865, when the smoke of war finally cleared, over six hundred thousand Americans, including forty thousand Black men, had lost their lives. But despite the pain and suffering brought about by war, four million newly emancipated men and women joyfully celebrated their freedom. In the words of formerly enslaved Susie Melton: "Never will forgit dat night of freedom. . . . An' all dat night de n----rs danced an' sang right out in de cold. Nex' mornin' at daybreak we all started out wid blankets an' clothes an' pots an' pans an' chickens piled on our backs, 'cause Missus said we couldn't take no horses or carts."[3] After two hundred and fifty years of enslavement and four years of war, surely they had earned their freedom. But soon it became clear that newly freed African Americans would continue to pay dearly as they pursued their hard-won rights and liberties. As the famous abolitionist and orator Frederick Douglass soberly remarked, "Verily, the work does not end with the abolition of slavery, but only begins."[4]

At that very same historical moment, Edmonia Lewis picked up her chisel to capture the joy and hope of emancipation; fifty years later, Meta Warrick Fuller sculpted her emancipation narrative, reflective of America's rampant racial prejudice and social injustice. To understand the differences in style and composition of Lewis's and Fuller's emancipation sculptures, the previous chapter explored the artistic and social influences on each artist; to understand the narrative differences between *Forever Free* and *Emancipation*, this chapter provides the historical context of the first fifty years of Black freedom.

◆　◆　◆

If the sounds of the Civil War were gunfire, the sounds of peace were footsteps: Black soldiers marching home, the newly freed

walking miles upon miles in search of family, and the joyful tread of the emancipated exercising their freedom to go when and where they wanted. Du Bois spoke to their jubilance, saying, "There was joy in the South. It rose like perfume—like a prayer."[5] But the joy was short-lived; the war had reduced the South to a scorched wasteland unable to feed its starving population. The loss of men to war, the destruction of property and equipment, the collapse of financial institutions, and devastating drought had stripped the South of economic viability. This set the stage for the bitter racial conflict to come, as the three major groups in the postwar South—white plantation owners, the Freedmen's Bureau, and newly emancipated African Americans—all pursued conflicting agendas for control of Black labor.[6] The white planters' perspective on the newly freed Black workforce is explained by General Carl Schurz:

> There appears to be another popular notion prevalent in the South. . . . It is that the negro exists for the special object of raising cotton, rice and sugar, and that it is illegitimate for him to indulge, like other people, in the pursuit of his own happiness in his own way. Although it is admitted that he has ceased to be the property of a master, it is not admitted that he has a right to become his own master.[7]

Freedmen were reluctant to return to the masters and back-breaking field work they had just left. The Emancipation Proclamation had granted them freedom of choice, and above all else, they wanted to become their own master. "The freedom, as I understand it, promised by the proclamation, is taken us from under the yoke of bondage, and placing us where we could reap the fruit of our own labor, take care of ourselves," observed the Reverend Garrison Frazier.[8] Therefore, the federal government's decision to rescind the land-grant promise of "forty acres and a mule" struck a cruel blow to the freedmen's aspirations for land ownership.[9] South Carolinian rice planter Francis Le Jau Frost

described the freedmen's sense of betrayal in a letter to his mother: "They [the freedmen] cannot understand . . . how it is that they can have been born & raised on the soil & yet not inherit it upon becoming free."[10]

Forced off land they believed they should own, and largely unable to purchase land, freedmen had limited employment options. They could request aid from the Freedmen's Bureau; work for their former enslavers in exchange for housing, food, and clothing; or sign a labor agreement to work the plantation owner's land for a percentage of the crops produced. Worse still, Southern states began passing laws known as "Black codes,"[11] which regulated what work African Americans could perform, limited what they could be paid, and forced them to sign labor agreements or face imprisonment and fines.

As a result, many Black men had no choice but to sign labor agreements with their former owners. Disadvantaged by a lack of education and at the mercy of their employers, Black workers were frequently the victims of oppressive work requirements and were cheated out of their pay. Formerly enslaved Arthur Greene described his experience: "Well, we stayed dar [on the plantation] til de yeah was out. Worked fer one forth of de crop. . . . Out dat forth of yours de marster took out his part fer yo' board. That left you wid nothin' an' God knows the 'jority of us had nothin.'"[12] Out of this continuous conflict between the freedman's desire for economic independence and the white planter's demand for cheap and steady labor, the sharecropping system would be born.

Under a sharecropping system, Black workers leased farmland from white owners in exchange for an agreed-upon share of the crop; thus, plantation owners acquired a dedicated workforce, and Black farmers controlled their own labor and profit. Sharecropping also freed Black workers from the slave-gang style of field work and white supervision, both hated relics of enslavement (figure 2.1). Black farmers pinned their hopes on sharecropping as a way to achieve economic freedom, but as the historian Leon Litwack

Figure 2.1: Dorothea Lange, *Zollie Lyons, Negro Sharecropper, Home from the Fields for Dinner,* photograph, 1939. Library of Congress, Prints and Photographs Division, FSA/OWI Collection LC-USF34-019904-E.

writes, this "illusion of independence" soon evaporated: "He [the Black farmer] worked the white man's land, planted with the white man's seeds, plowed with the white man's plow and mules, and harvested a crop he owed largely to the white man."[13] Gone was the exultant freedman celebrating the promise of emancipation; caught in a cycle of poverty, the freedman was barely surviving. Formerly enslaved Nellie Loyd summarizes the Black man's economic plight: "Atter de war de n----rs started up hill; den went back. Since dat time up to now, dey has been working most on farms. Some rent small farms and some work as wage hands or share-croppers."[14]

◆ ◆ ◆

For newly emancipated Black men, economic independence was key to their manhood and self-respect. Slavery, which

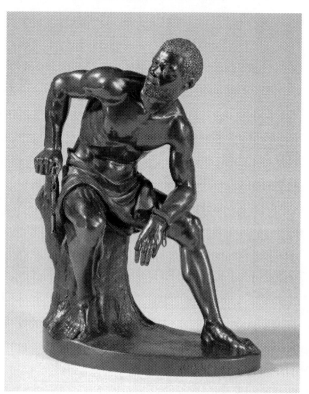

Figure 2.2: John Quincy Adams Ward, *The Freedman*, 1863. Courtesy of The Metropolitan Museum of Art, New York.

epitomized the lack of power and control, had dispossessed Black men of their manhood, and emancipation was seen as the only way to restore it. This symbiotic relationship between Black freedom and Black manhood is best articulated by art historian Michael Hatt in his description of the emancipation sculpture *The Freedman* (John Quincy Adams Ward, 1863) (figure 2.2). "[The freedman's] physique ... functions like the emancipation proclamation itself, conferring on the negro a new status of freedom, of masculinity, of subjectivity, a status described through the body."[15] Edmonia Lewis's *Forever Free*, completed in 1867, also depicts the connection

between freedom and Black manhood. Through the physicality and positioning of the freedman—head raised triumphantly, fist clenched defiantly—she celebrates his masculinity and conveys his rightful role as head of the household. Fifty years later, Fuller would observe that "the Negro has been emancipated from slavery but not from the curse of race hatred and prejudice."[16] Thus, in Fuller's freedman there is no joy, no expression of gratitude for freedom; his masculinity is seen as an intrinsic quality of his race rather than a bestowal. Similar to *The Freedman* by Ward, Fuller uses the physical elements of position, muscle, and facial appearance to depict the freedman's inherent manhood and proclaim his fitness as a free Black man.

◆ ◆ ◆

By the turn of the century, economic hardships facing African Americans required more and more women to work outside the home, eroding Black men's sense of empowerment and control. "Slavery and racism sought the emasculation of black men," writes historian James Horton, going on to explain that with freedom, "part of the responsibility of black men was to 'act like a man' . . . [and] the responsibility of black women was to 'encourage and support the manhood of our [Black] men.'"[17] In 1900, 83.6 percent, or 3.1 million African Americans, were employed in the following occupations: agricultural laborers, farmers, unspecified laborers, servants and waiters, and launderers. Of that number, 70 percent of Black breadwinners were engaged in farming-related occupations, compared to 40 percent of white breadwinners.[18] The 1900 census also reported that close to 41 percent of Black women were family breadwinners (figure 2.3), concluding that "the figures show clearly that in the case of Negro women marriage does not withdraw them from the field of gainful occupation to anything like the extent it does for white women."[19] The resulting tension between the freedman's efforts to establish his identity

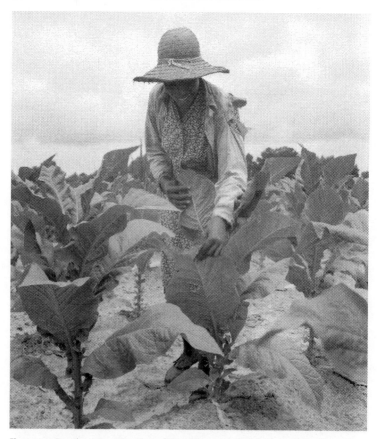

Figure 2.3: Dorothea Lange, *Daughter of Negro Sharecropper Goes Up and Down the Rows "Worming" the Tobacco*, photograph, 1939. Library of Congress, Prints and Photographs Division, FSA/OWI Collection LC-DIG-fsa-8b33875.

as a free man, and his inability to provide for his family without the economic support of his wife and children, often created a corrosive home environment. Educator and social activist Anna Julia Cooper gives an example of the caustic result, writing that a "[Black] man was once asked how many were in his family. 'Ten,' he replied grimly; 'my wife's a one and I a zero.' In that family there was harmony, to be sure, but it was the harmony of despotism—it

was the quiet of a muzzled mouth, the smoldering peace of a volcano crusted over."[20]

The emancipation sculptures of Lewis and Fuller speak to the nineteenth-century gendered roles of the newly emancipated as well as the domestic discordance caused by economic oppression and family separation. Prior to emancipation, plantation owners destroyed the coherence of Black families by dividing and scattering husbands, wives, and children across the slave-holding states. It is estimated that out of an enslaved population of four million, over half were separated from spouses and parents, and one in four were children.[21] In the months and years following emancipation, the newly freed made heroic but often unsuccessful efforts to reconnect with missing loved ones. Hundreds of "Information Wanted" notices, like the one below posted by Nancy Jones in 1886, were placed in newspapers across the North and South:

> Information Wanted of my son, Allen Jones. . . . He wrote me a letter in 1853 in which letter he said that he was sold to the highest bidder, a gentleman in Charleston, S. C. Nancy Jones, his mother, would like to know the whereabouts of the above named person.[22]

Efforts such as these would continue into the twentieth century, their plainspoken missives a testament to the deep family ties that endured despite the efforts of slave owners to destroy them.

The war also left many freedwomen as the sole breadwinner, desperately trying to care for children and older family members. Yet the image in *Forever Free* is a demure freedwoman kneeling joyfully, hands clasped in gratitude, a visualization that seems inconsistent with the nineteenth-century hardships levied on most Black women. Perhaps Lewis's freedwoman symbolizes the hopes of the newly emancipated in the *moment* of freedom rather than the reality of what is to come. In this moment of freedom, Black women could now aspire to reconnect the broken bonds of family and build new ones. Fifty years later, Fuller conveys a

different gendered message in her sculpture *Emancipation*, a message that is less about the reconstitution of the Black family and more about Black men and women's shared sufferings throughout the *journey* to freedom. Upon seeing Fuller's *Emancipation*, the educator Benjamin Brawley concludes that "Humanity is pushing them [the newly emancipated] out into the world, while at the same time the hand of Fate, with obstacles and drawbacks, is restraining them in the exercise of their new freedom."[23] With her knowledge of what is to come on the road to freedom, Fuller foreshadows the heartbreaking search and immeasurable loss of loved ones through the figures of Humanity and Fate.

◆ ◆ ◆

For the freedman, emancipation's promise of education was as important as the promise of land; he understood that education was the key to economic opportunities. "Free, then, with a desire for land and a frenzy for schools, the Negro lurched into the new day," observed W. E. B. Du Bois.[24] Despite the challenges of unequal funding for Black education, violence against students and teachers, fewer school days than white students, and crushing poverty, African Americans vigorously pursued their freedom to learn. In describing his schoolhouse, Arthur Greene states, "We had to set on old hard plain planks, plenty splinters in dem things; but do you know, baby, we was proud to git dat. No, us didn't keer, specially at de fust startin of learning."[25]

Black literacy was one of the few, yet important, successes of the Reconstruction period. The Freedmen's Bureau, charged with the mission of Black education, reported an overwhelming demand for schools, teachers, and books from the newly emancipated. "All around us the Freedmen are struggling hard against poverty," wrote an American Missionary Association employee in 1866, "yet they beg harder for school than for food or clothing."[26] By 1867, the bureau had established 960 day schools and 247 night

schools, and another 1,540 schools were being sustained by the freedmen themselves.[27] In total, the Freedmen's Bureau would spend over five million dollars on schools and teachers for the newly emancipated between June 1, 1865, and September 1, 1871.[28]

The investment paid off. The 1870 census reported that 180,372 Black children were enrolled in public schools; in 1880, that number had jumped to 856,123. The most critical measurement of improvement, though, was reflected in the African American literacy rate. In 1870 the literacy rate for African Americans was 20 percent; by 1900, this rate more than doubled, with 52 percent of African Americans able to read and write. Additionally, over 56 percent of Black children were enrolled in public schools and more than two thousand African Americans earned higher education degrees. Some two hundred schools and colleges had been funded exclusively by African Americans.[29] Given that when the Civil War ended less than 10 percent of newly emancipated African Americans were able to read or write, these achievements were astounding. In the words of the abolitionist and educator Charlotte Forten Grimké: "It is wonderful . . . how a people who have been so long crushed to the earth, so imbruted as these[,] . . . have so great a desire for knowledge, and such a capability for attaining it."[30]

◆ ◆ ◆

The freedman's battle for land and education was fierce, but it was the fight over the ballot that would be the most bitterly contested and violent. The Fourteenth Amendment, passed in 1868, and the Fifteenth Amendment, passed in 1869, recognized the Black man as an enfranchised citizen and ushered in a brief period of Black political engagement at the local, state, and national level. Eric Foner captures the importance of these amendments, observing that "[the Fourteenth Amendment] challenged legal discrimination throughout the nation and changed and broadened the meaning of freedom for all Americans."[31] Within three years of emancipation,

more than 80 percent of all freedmen had registered to vote, and over half a million freedmen cast votes in the 1868 presidential election of Ulysses S. Grant.[32] The same election ushered in two Black senators and twelve Black representatives to Congress, along with thousands of state and local officials. Black leaders, however, increasingly worried that the rise of violence against Black voters, coupled with the weakening of white commitment to Black self-determination, would ultimately reverse their hard-earned voting rights. In 1870, George Smith described the threats and intimidation he endured prior to the presidential election of Ulysses S. Grant in 1868:

> Large bodies of [white] men were riding about the country in the night for more than a month. They and their horses were covered with large white sheets, so that you could not tell them or their horses. They gave out word that they would whip every Radical in the country that intended to vote for Grant. . . . They sent word to me that I was one of the leaders of the Grant club, and they would whip me. . . . The Ku klux [sic] would go to the houses of all that belonged to the Grant club, call them to the door, throw a blanket over them and carry them off and whip them.[33]

In 1874, campaigning on a populist platform of "reducing the political power of blacks and reshaping the South's legal system in the interests of labor control and racial subordination" and using the tools of coercion and violence to diminish the Black vote, the Southern Redeemers and the Democratic Party achieved landslide victories over the Republicans.[34] Following this crushing defeat, the Republican Party's interracial coalition began to unravel. Less than a year later, Frederick Douglass warned, "The signs of the times are not all in our favor. There are, even in the Republican party, indications of a disposition to get rid of us."[35] His prophetic words would soon come true; by 1877, Reconstruction was officially branded a failure, federal troops had been withdrawn from the

South, and the enfranchisement promises of the Fourteenth and Fifteenth Amendments were disappearing. Worse, in 1896 the US Supreme Court decision *Plessy v. Ferguson* legalized segregation and further diminished Black political power.[36] Du Bois angrily characterized these assaults on Black civil rights as "the last great battle of the West; . . . [the Black man's] fight here is a fight to the finish. . . . Either he dies or he wins. . . . He will enter modern civilization here in America as a black man on terms of perfect and unlimited equality with any white man, or he will enter not at all."[37] With the loss of political representation and the weight of segregation upon them, the Black man's battle for equality became much more difficult.

◆　◆　◆

Fifty years after the end of slavery, and despite oppressive economic discrimination, African Americans could point with pride to numerous accomplishments. First, notwithstanding the onerous shackles of sharecropping, the number of Black-owned farms doubled between 1890 and 1910, achieving what historian Manning Marable describes as "a minor economic miracle in the Deep South."[38] According to Du Bois, "By 1909, African Americans owned 500,000 homes, and among these about 250,000 farms . . . with nearly 20,000,000 acres of farm land, worth about $250,000,000."[39] Additionally, a burgeoning Black middle class had arisen, to include "21,000 teachers and carpenters, 20,000 barbers, 20,000 nurses, 24,000 dressmakers and seamstresses, 10,000 engineers and firemen, 10,000 blacksmiths, [and] 2,500 physicians."[40] And as Henry Louis Gates Jr. observes, the Black community had established their own "segregated social and cultural institutions, especially churches, schools, colleges, self-help organizations, and fraternal organizations."[41] Given that African Americans were prohibited from participating in mainstream political and civic organizations, these institutions served more

than just a communal purpose, creating what architect Mabel Wilson calls a "Black counterpublic sphere" to pursue efforts the reinstate their civil rights and privileges.[42]

Within these fora, countering the dominant white narrative of racial inferiority with positive messaging was a priority issue for Black leaders. "[African Americans] fought to take back their image from the choking grasp of white supremacy in another kind of civil war," observes Henry Louis Gates Jr. "In this case, a war of representation, at times fought through culture and aesthetics."[43] The twentieth-century explosion of public fairs and expositions—often on a national scale—provided a highly visible platform to display African American achievements in science, history, and the arts to white Americans. Wilson makes the point that Black leaders saw these public venues as a way "to vigorously respond to how they [African Americans] were being positioned and portrayed . . . and disprove the bleak forecasts augured by their fellow white citizens by taking measure of their own advancement."[44] The 1913 National Emancipation Exposition, a national commemoration of the fifty-year anniversary of the Emancipation Proclamation, exemplifies this purposeful use of the "Black counterpublic sphere."[45] Entitled the "Jubilee of Freedom," Du Bois (the primary organizer of the exposition) made clear that the purpose of the event was to present a "bold counternarrative to American progress," specifying that:

1. It would encourage the colored people and make them strive to greater accomplishment in the future.
2. It would call the attention of the white people to the fact that the colored people are not criminals and loafers but on the whole, worthy striving citizens.[46]

Thus, On October 22, 1913, the Twelfth Regiment Armory in New York City opened its doors to the National Emancipation Exposition. Over the next ten days, thirty thousand visitors streamed in to

see what the *Washington Bee* called "the most complete exposition of Negro progress ever made."[47] Dozens of exhibitions, organized by topics such as "Manufactures and Inventions," "Art," and "Women and Social Uplift" were spread around an exposition floor festooned with maps, charts, models, photographs, and flowers.[48] Centered in the exposition's Temple of Beauty stood Fuller's *Emancipation* statue; over eight feet tall, art historian Renée Ater suggests that "*Emancipation* represented blackness on a monumental scale."[49] Du Bois's Jubilee of Freedom, described by *The Crisis* as "the largest single celebration which colored people have had in the North," provided a public space for African Americans to take pride in their history and achievements while also instilling a sense of hope for their future.[50]

◆ ◆ ◆

Forever Free and *Emancipation* serve as visual and historical signposts of the emancipation journey. In 1867, *Forever Free* reflected the first hopeful steps of freedom, and in 1913, *Emancipation* portrayed freedom's travelers in the face of the troubles to come. The two emancipation sculptures bookend fifty years of relentless white opposition to Black equality, a period Du Bois describes as "a fight against ridicule and monstrous caricature, against every refinement of cruelty and gross insult, against starvation, disease and murder in every form."[51] Lewis's and Fuller's honest and sympathetic sculptures of newly emancipated African Americans are a permanent reminder of a people's determination to win this fight.

"LIFTING AS THEY CLIMB"

Honey, de white man is de ruler of everything as fur as Ah been able tuh find out. . . .
So de white man throw down de load and tell de n----r man tuh pick it up. He pick it up
because he have to, but he don't tote it. He hand it to his womenfolks. De n----r woman
is de mule uh de world so fur as Ah can se.[1]
–Zora Neale Hurston, *Their Eyes Were Watching God*

So spoke Hurston's fictional character Grandma Nanny, a survivor of a lifetime of miseries: born into slavery, impregnated by her enslaver, and after emancipation, forced to scratch out a living as a single mother. Nanny's story reflects the real-life struggles of many newly emancipated Black women, such as Annie Wallace, born into slavery in 1852. After emancipation, Annie married and raised thirteen children, and although she never learned to read or write, "she saw that all of her own brood went [to school] as much as they could." Her husband died young, and Annie struggled to feed and clothe them, saying that she "made them shoes from the tops of old boots, cutting the soles out of the legs and using cloth for the top." Annie put her children to work gathering stray wool from the pastures, then "she carded, spun and wove [it] into cloth for their clothes."[2] Educator and civil rights activist Mary Church Terrell honored the spirit of Annie Wallace, and millions of other African American women, saying: "Colored women need not hang their heads in shame. . . . They are slowly

but surely making their way up to the heights, wherever they can be scaled. . . . Lifting as they climb, onward and upward they go struggling and striving and hoping."[3] Throughout the nineteenth century and beyond, Black women—regardless of their education, wealth, or class status—struggled under the twin burdens of race and gender discrimination.

Even Edmonia Lewis and Meta Warrick Fuller, both talented and intelligent professional women, could not escape the weight of these chains. In 1865, Lewis fled to Italy to escape racial discrimination, never to reside in America again. She explained her decision in an 1878 interview published in the *New York Times*: "I was practically driven to Rome in order to obtain the opportunities for art culture, and to find a social atmosphere where I was not constantly reminded of my color. The land of liberty is no place for a colored sculptor."[4] Decades later, Fuller would describe her struggles as a Black artist in a letter to Freeman Murray: "It is awful to feel that you have power that you cannot make use of."[5] Lewis and Fuller carried their battles against racial and gender injustice into their art, purposefully depicting strong, dignified Black women to counter popular nineteenth-century iconography of Black women as jezebels, mammies, and the like. This chapter explores not only Lewis's and Fuller's gendered perspectives of the Black emancipation experience, but the broader historical narrative of being a Black woman in America during the first fifty years of freedom.

◆ ◆ ◆

In 1865, 2.2 million enslaved women in the United States went free; most of these women could neither read nor write and lived a poverty-stricken existence in the rural South. In describing the lives of poor newly freed Black women, the Reverend Alexander Crummell, a pioneering African American minister and scholar, observed in 1868, "The truth is, 'Emancipation Day' found her [the

freedwoman] a prostrate and degraded being; . . . it has produced but the simplest changes in her social and domestic condition."[6] Similar to Annie Wallace's experiences, the life stories of these newly emancipated women are replete with sacrifice, hardship, and determination. "Freedwomen discovered during the first postwar months that peace literally had to be survived if freedom was to be defended or enjoyed," writes historian Leslie A. Schwalm. "The physical devastation of the countryside, the shortage of food, clothing, and the most basic necessities . . . all heavily increased the freedwomen's labor in their own homes."[7] Thousands of destitute Black women now found themselves as head of household, carrying the full burden of their family's survival. Victoria Perry, a formerly enslaved woman, interviewed for the Federal Writers Project, describes her mother's experience:

> After we were set free, I went with my mother to the Gist plantation down in Union. My mother always wanted to go back to her home at Bradford, Virginia, but she had no way to go back except to walk [from South Carolina]. Work was mighty scarce after slavery was over, and we had to pick up just what we could get.[8]

While plantation owners' demand for their labor was high, Black women resisted returning to work under the same conditions imposed under slavery. They were now free women and free laborers, with new domestic responsibilities; therefore, many Black women refused to return to field work or insisted upon more flexible working conditions to care for their families. They were unwilling to live on the plantation property, choosing to return to their own home at night; they knew the value of their work and negotiated higher wages. For the first time in their lives, often in the face of violent retaliation, Black women were in a position to put the needs of their families before the needs of their former enslavers.

Determined to distance themselves from their former status as slaves and affirm their new roles as wives and mothers, newly

emancipated women made visible changes to their clothes, hair, and attitudes. A letter written in 1870 by J. W. Alvord, general superintendent of education for the Freedmen's Bureau, captures the importance of these changes.

From linsey wolsey, ragged garments, clumsy brogans, or bare feet of former times, we notice the change to clothes of modern material; . . . it gives the adult population in the streets and churches an air strikingly in contrast with the menial raiment which slavery had clothed them. It is the costume of freedom, each choosing his or her own dress, according to taste, and all mainly in the respectable raiment of society around them.[9]

Whites reacted harshly to these perceived threats to their race-based social hierarchy. As historian Leon Litwack writes, "Black people quickly discovered that the line between impudence and the traditional subservience expected of them was perilously narrow."[10] All Black people endured the humiliation and pain of the racial etiquette required by whites, but Black women suffered most grievously. If a freedwoman improved her appearance or looked a white person in the eye, she was "uppity"; if she put the needs of her family before the needs of her white employers, she was "lazy"; and if she demanded fair payment and treatment, she was "unwomanly."

The freedwomen's pursuit of freedom was also at odds with the Freedmen's Bureau's vision for a new free labor society in the postwar South, one that included a Northern ideal of family life. The Bureau vigorously espoused a domestic model of marriage that included "independent manhood, dependent womanhood, and the 'proper' family structure."[11] Assistant Bureau commissioner Clinton Fisk further specified that a wife must "take good care of her person, be clean, neat, and look as pretty as possible. . . . A wife must do her very best to help her husband make a living. . . . Much of the beauty and happiness of home depends on the good sense, economy, and industry of the wife."[12] This traditional, gendered

view of nineteenth-century families stood in stark contrast to the grim living conditions of many Black women and children in the postwar South. Between June 1865 and August 1866 alone, the Bureau provided close to nine million rations of food to starving women and children.[13] But by 1866, worried about the spiraling cost of their relief efforts and influenced by complaints from white employers about Black women's resistance to work, the Bureau demanded Black women work or face the loss of any relief.

In truth, the economic reality of the post–Civil War South had already forced over a million newly emancipated women into the labor force.[14] The early emancipation hopes of freedom of choice had been dashed by the necessity of working where the white man told them to work. But the fires of freedom had been lit; through word and deed, Black women pushed back on the demands of their white employers. Outraged employers punished defiant Black women, sometimes severely, as reflected in these two examples by historian Leslie A. Schwalm:

> Two other freedwomen, as well as two boys, were flogged by a party of eight to ten white men "until the blood ran from their bodies." "The pretext for whipping these persons," reported the [Freedmen's Bureau] agent, "was that they were visiting on this place and that . . . was against orders." In another incident, a husband and wife and two other freedmen refused to sign a contract for life: the men were shot, while the freedwoman was stripped bare, given fifty lashes on her back, and forced to walk fifty miles to return to the planter's place.[15]

The exact number of Black women who were whipped, choked, mutilated, raped, and murdered by whites after the Civil War remains unknown. As historian Mary Farmer-Kaiser writes, "By challenging those who tied them up by their thumbs and beat, flogged, raped, maimed, and otherwise abused them, African American women also attempted to assert autonomy over their

lives as free women, as respectable women."[16] This battle, fought over the rights and identities of free Black women, was nothing less than a power struggle over the very definition of Black freedom.[17]

◆ ◆ ◆

Lewis's *Forever Free* expressively captures the freedwomen's struggle for life and liberty, influenced by her own experiences as a Black woman. For Lewis, subjected to racial discrimination and the victim of racial violence at Oberlin College, emancipation was deeply personal. When asked about her sculptural imagery and the broken shackles on the wrists of her Black subjects, she observed, "So was my race treated in the market, and elsewhere."[18] Upon moving to Boston in 1864, Lewis developed strong ties with the abolitionist community and other reform movements dedicated to the rights of women. Her relationships with other Boston-based female abolitionists, and exposure to sculptures of African womanhood by female sculptors—such as Anne Whitney's *Ethiopia*, Harriet Hosmer's *Zenobia in Chains*, and Louisa Lander's *Virginia Dare*—undoubtedly influenced Lewis's sculptural vision (figures 3.1, 3.2, 3.3).

Figure 3.1: Anne Whitney, *Ethiopia Shall Soon Stretch Out Her Hands to God*, or *Africa*, 1862–64. Destroyed. Courtesy of Wellesley College Archives, Library and Technology Services.

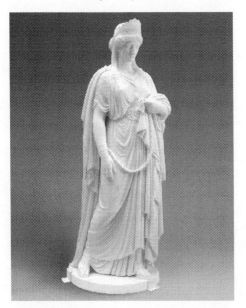

Figure 3.2: Harriet Hosmer, *Zenobia in Chains*, 1861. Courtesy of Saint Louis Art Museum, St. Louis, Missouri, American Art Purchase Fund.

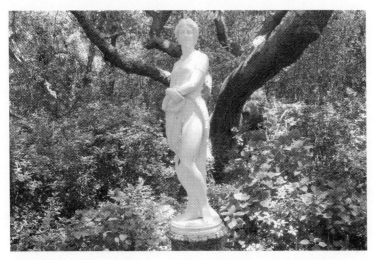

Figure 3.3: Louisa Lander, *Virginia Dare*, 1859–60. Elizabethan Gardens, Manteo, North Carolina. Photograph courtesy of DrStew82 (CC BY-SA 4.0), Wikimedia Commons.

Figure 3.4: "Am I Not a Woman and a Sister?" Seal of the Philadelphia Female Anti-Slavery Society, artist unknown. Schomburg Center for Research in Black Culture, Manuscripts, Archives and Rare Books Division, The New York Public Library.

As the name *Forever Free* implies, it was Lincoln's promise of freedom and the hope for racial equality for her people that inspired Lewis's emotional sculpture of the Black emancipation experience. Lewis's kneeling freedwoman also reflects the strong influence of anti-slavery imagery on Lewis's artistic vision, specifically the abolitionist image of a kneeling enslaved woman with the title "Am I Not a Woman and a Sister?" (figure 3.4). This icon of a female slave, hands and feet chained to the ground and unable to rise, was used in abolitionist literature to symbolize the horrors of slavery and the oppression of women.[19] Although the supplicating posture of Lewis's newly emancipated woman resembles the kneeling slave, the freedwoman's shackles are broken and she is now free; she moves upward, symbolizing the transition from slavery to freedom.

Lewis's aesthetic challenge of depicting Blackness in the neo-classical genre was compounded by what Dabakis calls the "contradictory identities that comprised freed black womanhood."[20] White women found artistic representation of Black women with softer, Eurocentric features more feminine, more sympathetic, and more acceptable. This popular, racialized image of Black women conflicted with Lewis's desire to capture their authentic spirit and appearance. In *Forever Free*, Lewis reconciles these contradictions by sculpting a freedwoman with a mixed-race countenance, refined facial features, and long, sleek hair, pleasing to white audiences. At the same time, she expresses the freedwoman's strength and power through her muscular body, reflective of a life of enslavement. As Dabakis points out, Lewis's representational compromise seems designed to allow "the freed slave to be read as 'woman' and the blackness to be legible."[21] Similarly, Buick suggests that by neutralizing the freedwoman's Blackness, Lewis has "shed all markers that would identify her [the freedwoman] as chattel. She is indeed 'free.'"[22] By softening the appearance of the freedwoman, Lewis minimizes the barrier between Black and white women and enhances the freedwoman's acceptance as a free woman.

For the newly emancipated, the now-legal act of marriage symbolized both their transition from slavery and their new status as free people. Through the posture and relative positioning of her two Black subjects in *Forever Free*, Lewis affirms their gender-specific roles in the new free Black family. The freedman stands above the kneeling freedwoman, one hand clasped tightly on her shoulder, the familial hierarchy clearly established. The freedwoman kneels in gratitude for her freedom, willing to sacrifice her personal liberty in exchange for her new role as wife and mother. Additionally, by accepting the gender-specific obligations of nineteenth-century marriage, Black women gained legal protections, such as due process in the case of physical assault, sexual violence, illegal child labor, and unfair labor practices. Throughout Reconstruction, Black women actively pursued justice and reparations in the

courts and through the Freedmen's Bureau. In fact, historian Mary Farmer-Kaiser notes that "the assertiveness of freedwomen is an important part of the Reconstruction experience."[23] Thus, Lewis's freedwoman exemplifies the millions of newly freed Black women who "out of economic necessity and the experience of slavery . . . fashioned a place for themselves in the post-Emancipation family and community."[24] Although Lewis's freedwoman kneels, she is no longer a cowering, subservient slave, but a free woman of strength and determination.

◆ ◆ ◆

Meta Warrick Fuller was born in 1877, the same year that the era of Reconstruction collapsed under the weight of retrenched politics, flawed policies, and racism. Growing up in a middle-class Black family in Philadelphia, Fuller may have been spared some of the worst of Jim Crow, segregation, or inequality, but she too suffered the sting of racism. Segregation divided northern neighborhoods and churches, as well as public facilities such as parks, beaches, playgrounds, and schools, into Black and white. For example, Atlantic City, New Jersey, which the Warrick family visited during the summer, had a segregated beach and "whites only" boardwalk. Historian Judith Kerr recounts Meta's racial isolation when forbidden to enjoy the carousel rides with her white companions: "As the calliope began to play and the carousel began to revolve, Meta would wait and pretend to be happy as her laughing, white friends rode the soaring mechanical steeds."[25]

In 1902, upon completion of her artistic studies in Paris, Fuller returned to Philadelphia only to discover that none of the city's white art dealers were interested in her work. Art historian Renée Ater captures Fuller's own words on why she was poorly received: "I was not taken up in America. . . . [When] I took my work to dealers, . . . they said, 'Oh, no,' they didn't buy domestic work . . . [but] that was work that I had done in Paris. But they couldn't see

that. It was racial, I think."[26] And in 1908, when newlyweds Meta and Solomon Fuller moved to Framingham, Massachusetts, they experienced racial discrimination when attempting to purchase their first house. After buying a lot in a predominantly white neighborhood, they were pressured to sell due to the strong objections of their soon-to-be neighbors. Their second purchase nearly met the same fate, but despite the threats, Meta and Solomon refused to leave.[27] The Fullers continued to struggle with discrimination; for example, only one heating company was willing to sell them fuel, and a petition demanding they leave was circulated around the neighborhood. Even Mary Church Terrell, a well-known African American activist and educator, was not exempt from the very real threats to African Americans living in white neighborhoods. In describing her unsuccessful effort to purchase a home, Terrell recounted the advice she received from her real estate agent: "It is a good thing for you that you didn't get that house. For, if you had moved into that neighborhood, you would have had all kinds of trouble. Nobody would have served you milk or ice. Both you and your daughters would have been stoned every time you went into the street."[28]

◆ ◆ ◆

At the turn of the twentieth century, as Fuller struggled to balance domestic responsibilities with her artistic career, the economic and social conditions for most African Americans were grim. Over 90 percent of the Black population lived in the South, working on farms or as low-wage domestic workers, and only about one-third of Black children regularly attended school. Between 1890 and 1910, over two hundred thousand African Americans migrated into the cities in search of jobs; the influx of unemployed workers into the cities, as well as increased violence and crime, threatened the infrastructure of urban Black communities. Black female activists, worried that these communities would deteriorate

irreversibly into poverty, were driven to intervene. Educator and author Paula Giddings observes, "Standing on the brink of this racial precipice, convinced they could save the race, Black women saw their role in almost ecclesiastical terms."[29] Black women such as educator and activist Anna Julia Cooper, for example, appealed to middle- and upper-class Black women "who are so sure of their social footing that they need not fear leaning to lend a hand to a fallen or falling sister." Cooper goes on to say, "'I am my Sister's keeper!' should be the hearty response of every man and woman of the [Black] race."[30]

Fuller heeded the call. As an educated Black woman and artist, Fuller likely felt a responsibility, or a duty, to use her art to affirmatively portray Black Americans and address the condition of her race. In *Emancipation*, her sculpture is both a visual narrative of Black freedom and message of racial uplift.[31] However, the depth of Fuller's passion about gender and racial injustice is best displayed in her 1919 sculpture *Mary Turner (A Silent Protest Against Mob Violence).*[32] This sculpture of the lynching of a pregnant Black woman conveys a strong message on the vulnerability of Black women to violence. Civil rights author and educator Julie Armstrong observes that this sculpture "offer[s] rich insights into the possibilities and limits of black women's creative response to racist violence, especially when that violence was turned against women themselves."[33] Although *Mary Turner* tackles the very real issues of Black resistance and mob violence, Fuller's imagery of a woman cradling her baby, surrounded by a mob and engulfed in flames, conveys a deeper, more personal meaning. Many years later, when Fuller was asked which African American woman she most admired, art historian Ater writes that Fuller "singled out [Mary Church] Terrell, a mother who took a strong moral and religious stand against lynching."[34]

Fuller was part of a growing number of skilled and educated African American women that included doctors, lawyers, writers, teachers, and artists who continuously struggled against the twin

barriers of race and gender. In the words of Mary Church Terrell: "Many people would be amazed. [*sic*] if they knew how huge and how high are some of the obstacles which confront a colored woman who has studied and achieved something worthwhile in spite of the terrible disadvantage under which she has labored."[35] Fuller herself struggled with the stereotype of womanhood and gendered expectations of her time. Not only did her husband's disapproval of her sculpture force her to choose social and domestic responsibilities over art, but she also felt herself an ill fit for the "high-class housewife" position. Fuller even built a studio down the street from her home to escape her domestic duties, keeping the effort a secret from her husband as long as possible. She voiced her frustrations in balancing her domestic responsibilities with her artistic pursuits in a letter to Freeman Murray. She writes, "I am so tired out trying to keep all my 'irons in the fire.' Housework, nursing, sculpture, and occasional church work, but they don't mix no matter how carefully I introduce the 'ingredients.' . . . I am tired out body and soul, and I see no chance of any change."[36]

Despite Fuller's concerns over her artistic career, in 1913, she was commissioned by W. E. B. Du Bois to create the cornerstone sculpture for the fifty-year anniversary celebration of the Emancipation Proclamation. She expressed her excitement to Murray, writing, "I did the work for a very low figure of $200 over expenses—the actual expenses amounted to much more, but I was anxious to do the work because I loved it and I hoped it would be an opening for me."[37] Inspired by the accomplishments of a people bent low by the weight of racism and social injustice, Fuller's *Emancipation* conveys an uplifting narrative of their dignity, strength, and empowerment. In *Emancipation*, Fuller used both art and allegory to go beyond a visual expression of the *moment* of freedom to express the much broader narrative of the *journey* to freedom. Through Humanity's foreboding of the brutality to come, and as the branches of Fate overshadow their journey, Fuller captures the pain and sacrifice that accompanied her travelers over the

first fifty years of freedom. But through the physical framing of her subjects, Fuller also conveys a message of hope and uplift. The posture of the freedman and freedwoman is tall and regal, suggesting pride in their African lineage and their determination to be free; art historian Ater observes that Fuller's unclothed subjects "represent the African American yet untouched by education and social acculturation."[38]

Upon seeing Fuller's *Emancipation*, Freeman Murray writes: "Three figures almost motionless, instead of a group in action. We do not ask merely, what are they doing? We are impelled to seek the deeper meaning and purpose. And the more there develops of the artist's message of longing, of hope, of sorrow, introspectively, 'in the heart'—the finer does the group appear."[39] But one wonders—did *Emancipation*'s message of uplift and empowerment connect with her African American audience? In a letter to Murray, Fuller writes that Du Bois was not satisfied with the final result: "He [Du Bois] seemed all enthusiasm until the thing arrived at the hall and from that time on he seemed to ignore me."[40] The reason for his possible dissatisfaction is unknown; perhaps the nudity of her subjects, or their connection to an "uncivilized" past, was inconsistent with his vision of racial uplift. At the conclusion of the National Emancipation Exposition, Fuller would move *Emancipation* back to her home and unsuccessfully attempt to secure funding for the final casting of the statue; ultimately, it would sit in Fuller's garage for another eighty-five years before it was finally completed. Even her friend Freeman Murray was unsure if *Emancipation* had resonated with the exposition audience, asking himself: "Has she succeeded? Some will wag their heads and murmur ruefully: 'There is yet more to be said.' Perhaps it is so."[41] But to Fuller, it was one of her greatest works; when asked in a 1964 interview to name her greatest contributions to "the race," she cited "her artwork for the Jamestown Tercentennial Exposition, the National Emancipation Exposition, and the America's Making Exposition."[42]

◆ ◆ ◆

Edmonia Lewis and Meta Warrick Fuller were as complicated and compelling as the women they sculpted. They never wanted to be pigeonholed as "race" artists or be held to some lesser artistic standard because of their gender. Racism and gender discrimination, however, were always a part of their lives. Remember that as Lewis worked in her studio in Italy, customers came in and "demanded to watch her work—unable to believe that black people were capable of artistic creation."[43] Remember that Fuller, after receiving the prestigious gold medal for artistic excellence at the Jamestown Tercentennial Exhibition, was refused restaurant service because of the color of her skin.[44] And yet they climbed. In 1871, Lewis stated, "I have strong sympathy for all women who have struggled and suffered."[45] We see the truth in her words, from her trailblazing depiction of Black women in neoclassical art, to her unprecedented depiction of the newly emancipated in *Forever Free*. In *Emancipation*, Fuller bequeathed us a different vision of the Black emancipation experience, one that turned tired artistic tropes of Black servility and white liberation on their head. The result was "sculpture [that] spoke to the essence of the black experience in America."[46]

The accomplishments of these two women are echoed in the words of Mary Church Terrell: "In spite of handicaps and discouragements they are not losing heart. . . . Lifting as they climb, onward and upward they go struggling and striving and hoping. . . . Seeking no favors because of their color nor charity because of their needs they knock at the door of Justice and ask for an equal chance."[47] That is all Edmonia Lewis and Meta Warrick Fuller, along with millions of other African American women, asked for—*an equal chance*. Lewis's and Fuller's historical artwork, *Forever Free* and *Emancipation*, accords us all an equal chance to listen to, and learn from, these amazing women.

NEVER FORGET

Whatever else I may forget, I shall never forget the difference between those who fought for liberty and those who fought for slavery; between those who fought to save the Republic and those who fought to destroy it.
–Frederick Douglass (1883)

With these words, Frederick Douglass—former slave, abolitionist leader, political activist, and passionate defender of Black rights—made clear that any historical memory devoid of slavery as the cause of the Civil War, or Black emancipation as the intended outcome, was unacceptable. To Douglass, freedom was not only the reward for winning the Civil War, but it was also the foundation for building a new interracial nation. Thus, to forgive the sins of slavery and betray the cause of Black freedom was *simply not an option*. But emancipation had set in motion a new battle, described by historian Kirk Savage as "a momentous struggle over the idea of race and the terms of citizenship in a nation supposedly dedicated to equality."[1] Southern whites, anxious to preserve the nation's white national identity and recognizing the vital link between memory and identity, initiated a successful campaign to reinterpret their past. This version of antebellum history, often called the "Lost Cause," reimagined the Civil War as a conflict between equally dedicated and brave white men while minimizing the suffering of four million enslaved people. The Lost Cause revision to the

historical narrative of slavery, often depicting plantation owners as benevolent "masters" applying their power for the greater good of their Black workers, reinforced the principles of white exceptionalism and Black inferiority. This "new" historical narrative, replete with benign slavery and heroic soldiers, was consciously designed to reinforce white superiority.

Douglass recognized the threat posed by the public acceptance of this revised historical narrative of the Civil War. To Douglass, "historical memory was the prize in a struggle between rival versions of the past, a question of will, of power, of persuasion," writes David Blight.[2] But by the 1880s, Americans wanted a reconciliation between the North and South and a healing of the rift between those who had fought each other during the Civil War. Additionally, there was growing public desire for a historical narrative that emphasized mutual heroism on both sides, while minimizing slavery and racial conflict. As Kirk Savage points out, "The ideal of a new interracial order vanished from the public space."[3] By 1890, the age of public monuments dedicated to this new historical narrative was well underway, and hundreds of Confederate statues and memorials arose from the ashes of the Civil War. Like the mythical phoenix that is consumed by flames only to rise again, the incineration of slavery led to the rebirth of white supremacy, or slavery by a different name.

These memorials dedicated to white Confederate soldiers and leaders accomplished two critical objectives: they publicly validated and reinforced the false Lost Cause narrative and reconfirmed white supremacy in the post–Civil War era. Sociologist Ron Eyerman describes the resulting pain and trauma inflicted on nineteenth-century African Americans: "As the nation was re-membered through a new narration of the war, blacks were at once made invisible and punished. Reconstruction, and blacks in general, were made the objects of hate, the Other, against which the two sides in the war could reunite and reconcile."[4] Throughout history, control of public memory has often been wielded as a

weapon; if you (or people who look like you) are invisible in the public historical landscape, what does that say about your identity? This chapter explores how the Lost Cause memorial landscape purposefully diminished America's history of slavery and emancipation, and how Lewis's and Fuller's powerful visualization of the Black emancipation experience can reshape our understanding of this critical period of American history.

◆ ◆ ◆

History and memory trip each other up. How many of us have been certain of something in the past, only to realize that how we remembered it was not how it actually happened? History is the record of the past, based upon legitimate historical documents and ephemera. The factual history of Civil War battles is well documented in military orders, battlefield maps and reports, eyewitness accounts, and the like. Memories, however, are what we choose to remember (or forget), based upon what we know, believe, or value. Just ask any two people about their memory of a shared event, and you will likely hear two different versions. Memories also evolve over time, often creating inconsistencies between the historical record and our historical memory. As Blight points out, "People jealously seek to own their pasts."[5]

Blight further explains the importance of collective memory in American society: "Collective memories are instruments of power . . . wielded for political ends, to shape social policy, and for control of the historical narrative."[6] Thus, to have power in a society is to be able to shape the group's historical and collective memory and establish the accepted world order and the individual's place in it. Frederick Douglass understood that for African Americans, the loss of their collective memory of slavery was to risk losing not only their shared past but their shared identity as "former slaves." For the Black community to take collective action against racism, the memory of slavery must serve as a unifying force. Douglass

therefore implored Black audiences to never forgive or forget, saying, "Well the nation may forget . . . but the colored people of this country are bound to keep fresh a memory of the past till justice shall be done them in the present."[7]

◆ ◆ ◆

The newly emancipated Americans were eager to remember emancipation, to honor and celebrate their history, and to envision a future of equality and self-determination. African Americans enthusiastically organized public and private commemoration activities, including speeches, parades, and ceremonies, to celebrate their new identity as free Black citizens. It was during these early days of freedom that Edmonia Lewis completed *Forever Free*, her artistic commemoration of Black emancipation. Lewis visually depicts the joy and hope of a newly freed people, such as those described in this 1866 *Daily Dispatch* report on "a grand celebration" of emancipation: "The colored population to-day celebrated emancipation in the District of Columbia. Four to five thousand persons were in the parade, while probably ten thousand thronged the streets through which they passed, waving hats and handkerchiefs, and cheering as the line passed them."[8] As Reconstruction progressed, however, white southerners grew increasingly hostile toward Black commemorative activities. They felt threatened by these public displays of Black freedom and appalled by efforts to integrate slavery and emancipation into the South's historical record. Historian Kathleen Clark writes: "The challenge posed by such vigorous displays of black liberty and equality was not lost on unhappy whites, who viewed the freedpeople's parades as unwelcome evidence of black agency."[9]

Political leaders in the South understood that shaping the nation's collective memory of the Civil War—what is remembered and how it is celebrated—was critical for the continuation of white supremacy. Using the tools of discriminatory laws and disenfran-

chisement, white southerners took back the public commemorative space, forcing Black celebrations to side streets and outlying parade grounds. Thus, by the turn of the century, Blackness had all but disappeared from both the public space and the public view. The result, writes Savage, was that "the nation was recast more powerfully than ever before in the mold of the ordinary white man, leaving the black body once again on the margins."[10]

As the fifty-year anniversary of emancipation approached, the bifurcation of America's historical memory of slavery and emancipation along the color line was complete. Whites "owned" the antebellum history, with its fabricated Lost Cause narrative, displayed in statues and memorials across the public space. Black citizens maintained their historical legacy within the Black community, invisible to whites. The lasting influence and power of the Lost Cause memorials—even into the twenty-first century—are underscored by author and former New Orleans mayor Mitch Landrieu in this vignette about Black life in his city: "Terence [Blanchard] knew that every day, to get to his high school, . . . he had to pass by a mounted white warrior [Robert E. Lee], a symbol of the war to preserve slavery. Terence got the message promoted by the United Daughters of the Confederacy, politicians, and city officials associated with the Lost Cause all those decades ago. . . . Terence got it, he swallowed it, and he hated it."[11]

◆ ◆ ◆

In 1916, civil rights activist Freeman Murray voiced his concerns about the degrading representation of African Americans in the Lost Cause sculptures: "Emancipation—even under the circumstances through which it came about in this country—is conceived and expressed nearly always as a bestowal; seldom or never as a restitution."[12] Murray fully understood what art historian Albert Boime would later describe as "the politics of visual experience," where "images of emancipation, like the actual emancipation rituals

and ceremonies, were designed to emphasize the dependence of the emancipated slaves upon their benefactors."[13] Du Bois was equally disturbed by the ongoing "politics of visual experience," fearing that the sheer volume of these racist narratives would drown out any effort to build a new and positive collective identity for African Americans. Black leaders struggled to counter the revisionist versions of slavery popularized in early twentieth-century art, books, newspapers, advertisements, and films. One of the most egregious examples was the 1915 release of D. W. Griffith's movie *The Birth of a Nation*, which, historian Ibram X. Kendi writes, "enabled millions of Americans to feel redeemed in their lynching and segregation policies."[14] Du Bois angrily summarized fifty years of racist history and iconography: "In order to paint the South as a martyr to inescapable fate, to make the North the magnanimous emancipator, and to ridicule the Negro as the impossible joke in the whole development, we have in fifty years, by libel, innuendo and science, so completely misstated and obliterated the history of the Negro in America . . . it is almost unknown."[15] Well into the twentieth century, academic scholars continued to validate the "rightness" of many of America's racist practices, embracing the victimization of whites, the benevolence of slave owners, and a race theory that African Americans were savages and unsuited intellectually for citizenship.

◆ ◆ ◆

As early as 1935, Du Bois predicted that American youth "would in all probability complete [their] education without any idea of the part which the black race has played in America."[16] Sadly, his words would prove to be all too true, and the Lost Cause myth would become an accepted rubric in American education. For example, in describing the textbooks used to teach Virginia history, writer Bennett Minton quotes the following from a 1967 history textbook: "A feeling of strong affection existed between masters and slaves in a majority of Virginia homes. . . . It cannot be denied that some

slaves were treated badly, but most were treated with kindness."[17] And in 1965, author James Baldwin reflected on his educational experience, writing, "I was taught in American history books that Africa had no history and that neither had I. I was a savage about whom the least said the better, who had been saved by Europe and brought to America. Of course, I believed it. I didn't have much choice. These were the only books there were."[18]

The lack and misrepresentation of Black history in our educational institutions has been shameful. And despite the sincere efforts of many educators to correct the content, the results have been uneven; often the curriculum focuses only on the history of famous African Americans or is a sanitized version of Black history that avoids controversial issues. In January of 2022, the Zinn Education Project published a national report stating that "[social studies] standards that influence how the Reconstruction era is taught in U.S. schools are at best inadequate. In more than a dozen states, they still reflect century-old historic distortions that justified denying Black Americans full citizenship."[19] Not only are educators challenged to find acceptable curricula, but they are also competing with more compelling sources of information available to younger generations of Americans that often provide inaccurate and biased versions of Black history. Our social media capabilities allow racist thoughts, beliefs, and themes to continuously emerge across the internet. As soon as one is knocked down with the truth, another one emerges somewhere else. "As Americans have discarded old racist ideas, new racist ideas have constantly been produced for their renewed consumption," observes Ibram X. Kendi. "That's why the effort to educate and persuade away racist ideas has been a never-ending affair in America."[20]

How, then, to inspire Americans to learn and reflect on the unvarnished history of slavery, emancipation, and Reconstruction? As author and educator John McWhorter points out, "A history of horrors cannot inspire."[21] By presenting the first fifty years of Black freedom as only a thick, wet cloud of racist and violent facts misses the opportunity for students to engage in

a richer narrative of nineteenth-century Black life. One of the observations of the Zinn Education Project is that "Reconstruction is full of stories that can help us see the possibility of a future defined by racial equity. However, too often the story of this grand experiment in interracial democracy is skipped or rushed through in curricula and classrooms."[22] By studying emancipation and Reconstruction from the perspective of ordinary Black Americans—through their stories and lived experiences—we better understand the historical and human truth of this important era. At the 2016 dedication of the National Museum of African American History and Culture, President Barack Obama reflected on the importance of everyday Black Americans and their contributions to our country's history: "We rightfully passed on the tales of the giants who built this country, who led armies into battle, . . . but too often we ignored, or forgot, the stories of millions upon millions of others, who built this nation just as surely, whose humble eloquence, whose calloused hands, whose steady drive, helped to create cities, erect industries, build the arsenals of democracy."[23]

It is these stories, told by a people who built vibrant communities and led purposeful lives despite the challenges of racial discrimination, that engage not just the head, but the heart. As art historian Jules Prown explains, "History can never completely retrieve the past with all of its rich complexity. . . . We retrieve only the facts of what transpired; we do not retrieve the feel . . . of what it was like to be alive in the past."[24] Integrating nineteenth-century historical artifacts into the learning experience—to include personal narratives, vernacular traditions, literature, and art—allow the learner to explore "what it was like to be alive in the past." Thus, as historical artifacts, Lewis's and Fuller's emancipation sculptures are a permanent historical record of the Black emancipation experience. More importantly, their visual narrative about ordinary African Americans who built this nation with "calloused hands" brings the rich history of Black freedom to life.

Just imagine if, instead of Confederate statues, sculptures by Black artists such as Edmonia Lewis and Meta Warrick Fuller had graced the post–Civil War landscape. Or if the history of slavery and emancipation, along with the accomplishments of Black men and women, had been fairly represented in our nation's history books. But of course, that is not what happened. After the Civil War, a grief-stricken nation demanded statues and memorials to remember the fallen; over the next fifty years, some five hundred statues, monuments, and historical markers would ascend across the public landscape. With the notable exception of Thomas Ball's 1876 sculpture *Emancipation Memorial*, however, all were dedicated to white warriors and the Lost Cause mythology.[25] In contrast, Lewis's and Fuller's emancipation sculptures and their narrative of Black freedom remained hidden from public view. After its dedication ceremony in 1869, *Forever Free* remained in private hands until 1967, when it was acquired by Howard University in Washington, DC, and placed in the university's art gallery.[26] And with the completion of the National Emancipation Exposition in October 1913, *Emancipation* disappeared into Fuller's garage in Framingham, Massachusetts, where it would remain for eighty-five years. In 1999, the National Center of Afro-American Artists and the Museum of Afro-American History in Boston funded the bronzing of *Emancipation* and secured it a permanent home on Boston's Emancipation Trail. Fuller never witnessed public recognition of her emancipation sculpture.

Unlike the Confederate memorials, however, *Forever Free* and *Emancipation* live on, perpetual envoys of Lewis's and Fuller's visual expressions of the Black emancipation experience. Current and future generations can study these sculptures and ask the same questions posed by Freeman Murray in 1916: "What does it [the sculpture] mean? What does it suggest? What impression is it likely to make on those who view it? What will be the effect

on present day problems, of its obvious and also insidious teach-ings?"[27] Over the past 150 years since emancipation, America's perspective on race and gender has changed, and today's viewer would likely answer Murray's questions quite differently than a nineteenth- or early twentieth-century audience. Does that render these sculptures as nothing more than dated and dusty historical relics of a previous era? The answer is a resounding no. *Forever Free* and *Emancipation* provide both a historical narrative of the Black emancipation experience and a moral narrative of America's failure to create a nation where everyone is "created equal." By understanding our past, we understand the present. Art historian Tiffany Washington emphasizes this point, writing that "it is our duty to use these very works as a tool to teach more contemporary concepts and learn from our culture's mistakes."[28]

As historical artifacts created during the first fifty years of Black freedom, *Forever Free* and *Emancipation* are most assuredly educational tools for understanding the social, economic, and political history of African Americans. Their historical narrative challenges twenty-first-century learners to question and examine issues such as race in America, the role of Black women in the post–Civil War South, the repercussions of Reconstruction on Black freedom, the influence of "Lost Cause" memorials on the Black community, and so on. And by studying this history from the perspective of those who lived it, as Prown points out, "we see with their eyes and touch with their hands."[29]

◆ ◆ ◆

Throughout our history, the stain of racism has permeated our law-making bodies, our public institutions, our businesses, and even our neighborhoods—leaving a legacy of white power and marginalized nonwhite communities. And from slavery to emancipation to civil rights, African Americans have continuously fought for the right to be seen and heard as equals within a society that has tried to

prevent it. Then, on January 6, 2022, we witnessed the storming and occupation of the nation's Capitol building, prompting the following observation by historian Eric Foner: "The sight of people storming the Capitol and carrying Confederate flags with them makes it impossible to not think about American history. . . . The events we saw reminded me very much of the Reconstruction era and the overthrow of Reconstruction, which was often accompanied, or accomplished, I should say, by violent assaults on elected officials."[30] In waving the symbol of white supremacy over our nation's seat of power, what does that say about our national identity?

The question, then, is whether Americans are willing to do the hard work of eradicating racist ideas and racial discrimination. If so, the first step is a truthful examination of the history and impact of racial inequality. Freeman Murray observes that "art's value is to state a true thing or *to suggest a true thought*."[31] Thus, through the powerful and honest imagery of Lewis's and Fuller's emancipation sculptures, we can

see the humanity of four million newly emancipated African Americans,
learn from those who took the difficult journey to freedom, and
discover the true history of the Black emancipation experience.

Forever Free and *Emancipation* are not just historical memory; they are the uplifting narrative of a people's determination for freedom. Lewis's and Fuller's Black subjects do not crouch in servitude but stand with the dignity of an empowered free people, challenging America's racial prejudice and demanding equality. They faced a nation intent on maintaining a racist status quo; and yet, they continued down the road to freedom, fueled by purpose and hope. Let their message of hope, along with the motivating life stories of the newly emancipated, inspire you.

ALEX BOSTIC, AMERICAN ARTIST

Forever Free by Edmonia Lewis and *Emancipation* by Meta Warrick Fuller are a gift to all Americans. Although Lewis and Fuller have largely been forgotten, they produced some of the finest examples of American sculpture. But as nineteenth-century African American women, they faced race and gender discrimination throughout their careers. In 1865, Lewis moved to Rome, a place more welcoming to artists of color, to build a successful career as a neoclassical sculptor; in 1899, Fuller would study sculpture in Paris to elevate her craft, only to return to a segregated country. It is my honor to write about Edmonia Lewis and Meta Warrick Fuller in recognition of their contributions, their talent, and their struggles. At a time when Black women faced incredible difficulties, Lewis and Fuller courageously pursued their dream and love of their art. Few artists today would have sacrificed so much.

Why are they important? First, I point to the outstanding quality of their work. The skill it takes to master the art of sculpture is intense; as an artist myself, I took time out to study sculpture, and I understand the complexities and challenges of this artistic medium. Unlike painting, sculpture is three-dimensional art that the viewer sees from multiple angles—front, back, two sides, and above. I believe the detail and craftmanship in Lewis's and Fuller's sculptures, now on display in galleries and museums nationwide, are as good, or better, than any other European or American artist.

And these emancipation sculptures are not only outstanding examples of nineteenth-century fine art. Lewis and Fuller have given us two wonderful pieces of history that can teach the pain, struggle, and strength of African Americans to our children and generations to come. As an artist and art educator, I have long advocated for educating the public on Black art and the story that it tells. African Americans are a part of the American experience, and we also have a unique heritage of Black freedom. But the teaching of Black history and Black art in our schools and universities is spotty at best. Art students and educators alike need more historical information on where they have come from and where they are going. This book, with its historical narrative of Lewis's and Fuller's struggles and their emancipation sculptures, needs to be in every university art and art history program; learning the history of how artists of color have contributed to American art inspires future generations to pursue their passion. *Pieces of Freedom* ensures that our work will be counted, along with the work of many other artists, in the history of this nation's art.

NOTES

Introduction

1. David W. Blight, *Beyond the Battlefield: Race, Memory, and the American Civil War* (Amherst: University of Massachusetts Press, 2002), 234.

2. The Lost Cause refers to the revised version of Civil War and antebellum history that was promulgated in art, literature, and popular media after the Civil War. Designed to recast the Civil War as the "War Between the States" rather than a war over slavery, the Lost Cause reimagined the Civil War as a conflict between equally dedicated and brave white men, elevating the valor of the white soldier while minimizing the contributions of Black soldiers and the suffering of four million enslaved people.

3. Kirsten Pai Buick, *Child of the Fire: Mary Edmonia Lewis and the Problem of Art History's Black and Indian Subject* (Durham, NC: Duke University Press, 2010), 4. The actual dates of Edmonia Lewis's birth and death have long been in question, but I have used the dates determined by Buick. She establishes Lewis's birth year as 1844, based on Lewis's passport application, and the year of her death as 1909, based on Lewis's signature in a reception book. For additional details, see pages 4–28. Lewis's full name is Mary Edmonia Lewis; however, throughout this book she is called Edmonia Lewis, the name she used throughout her life.

4. *Forever Free* by Edmonia Lewis remained in private hands until 1967, when it was donated to Howard University, and is now located in the Howard University Gallery of Art. At the conclusion of the National Emancipation Exposition in 1913, Meta Warrick Fuller's statue *Emancipation* was stored in her garage until 1998. The National Center of Afro-American Artists and the Museum of Afro-American History in Boston funded the completion and bronzing of *Emancipation*, which was unveiled in June 1999 in Harriet Tubman Square in Boston's South End.

5. DeNeen L. Brown, "How the Founder of Black History Month Rebutted White Racism in a Forgotten Manuscript," *Washington Post*, February 1, 2019, https://www.washingtonpost.com/history/2019/02/01/how-founder-black-history-month-refuted-white-racism-forgotten-manuscript.

6. Claire Parfait, Hélène Le Dantec-Lowry, and Claire Bourhis-Mariotti, introduction to *Writing History from the Margins: African Americans and the Quest for Freedom*, ed. Claire Parfait, Hélène Le Dantec-Lowry, and Claire Bourhis-Mariotti (New York: Routledge Press, 2017), 4.

7. Freeman Henry Morris Murray, *Emancipation and the Freed in American Sculpture: A Study in Interpretation* (Washington, DC: Murray Brothers, 1916), 61.

8. Meta Warrick Fuller to Freeman Henry Morris Murray, January 1915, box 74–1, folder 6, FHM Murray Papers, Manuscript Division, Moorland-Spingarn Research Center, Howard University, Washington, DC. Of note, Fuller wrote Murray at least eight letters between January 1915 and January 1916.

9. Phebe Ann Hanaford, *Daughters of America: Or Women of the Century* (Augustus, ME: True, 1882), quoted in Buick, *Child of the Fire*, 60.

10. Buick, *Child of the Fire*, 35.

11. Peter Gay, *Art and Act: On Causes in History—Manet, Gropius, Mondrian* (New York: Harper and Row, 1976), 12–14. Peter Gay identified three distinctive influences on the way a piece of art is created, which include "culture," defined as a complex mixture of social status, codes of conduct, and environmental influences; "craft," which is the domain of work, training, and habit; and "privacy" or "personality," the intimate world of family and the inner life of the artist.

12. Barbara Welter, "The Cult of True Womanhood: 1820–1860," *American Quarterly* 18, no. 2 (Summer 1966): 152, https://doi.org/10.2307/2711179. Welter defines the attributes of "true womanhood" as "divided into four cardinal virtues—piety, purity, submissiveness and domesticity. . . . Without them, no matter whether there was fame, achievement or wealth, all was ashes. With them she was promised happiness and power."

13. W. E. B. Du Bois, *The Souls of Black Folks* (New York: Dover Publications, 1994), 4.

14. Blight, *Beyond the Battlefield*, 193.

15. Zinn Education Project, "Report: State by State, U.S. School Standards for Teaching Reconstruction are Failing Students," media release, January 2022, https://www.teachreconstructionreport.org/release.

16. Welter, "Cult of True Womanhood," 152.

17. Ibram X. Kendi, *Stamped from the Beginning: The Definitive History of Racist Ideas in America* (New York: Bold Type Books, 2016), 286–87. Dunning refers to William Archibald Dunning, the director of Columbia University's Dunning School of Reconstruction History. Kendi takes issue with Dunning's 1907 publication titled *Reconstruction: Political and Economic, 1865–1877*, which purportedly presented the truth about Reconstruction. Dunning describes "the White South as victimized by the corrupt and incompetent Black politicians, and the North mistakenly forcing Reconstruction before quickly correcting itself and leaving the noble White South to its own wits." Additionally, the Zinn Education Project report entitled *Erasing the Black Freedom Struggle: How State Standards Fail to Teach the Truth About Reconstruction*, describes Dunning's work as "distorted scholarship [that] casts Reconstruction as an illegitimate, reckless enterprise that justifiably failed."

18. Tiffany Washington, "Made in America: A Critical Revisionism to Revive the Canon," in *American Art: Collecting and Connoisseurship*, ed. Stephen M. Sessler (London: Merrell Publisher, 2020), 243.

Chapter 1: Women of Mark

1. Fuller to Murray, January 1915, FHM Murray Papers.

2. Susan E. Frazier, "Some Afro-American Women of Mark," in *The Portable Nineteenth-Century African American Women Writers*, ed. Hollis Robbins and Henry Louis Gates Jr. (New York: Penguin House, 2017), 586.

3. Frazier, "Some Afro-American Women of Mark," 603.

4. Margaret Just Butcher, *The Negro in American Culture* (New York: Alfred A. Knopf, 1966), 220. Fuller's maiden name was Meta Vaux Warrick.

5. Welter, "Cult of True Womanhood," 152.

6. Lewis titled her sculpture *Forever Free*, using President Lincoln's own words in the Emancipation Proclamation: "all persons held as slaves within any State or designated part of a State . . . shall be then, thenceforward, and forever free." Abraham Lincoln, Emancipation Proclamation, January 1, 1863, Presidential Proclamations, 1791–1991, Record Group 11, General Records of the United States Government, National Archives, https://www.archives.gov/exhibits/featured -documents/emancipation-proclamation/transcript.html.

7. Charmaine Nelson, *The Color of Stone: Sculpting the Black Female Subject in Nineteenth-Century America* (Minneapolis: University of Minnesota Press, 2007), 184.

8. "Edmonia Lewis," *West Chester (PA) Morning Republican*, May 17, 1871, Nineteenth Century US Newspapers, accessed October 13, 2022, https://www .gale.com/c/nineteenth-century-us-newspapers.

9. Henry Wreford, "A Negro Sculptress," *The Athenaeum*, March 3, 1866, 302. The terms Ojibwa and Chippewa are used interchangeably to describe the same Native American tribe.

10. "Miss Edmonia Lewis," *Portland (ME) Transcript*, July 23, 1876, 133.

11. Buick, *Child of the Fire*, 8–10. Although there are numerous publications on the life of Edmonia Lewis, Buick's book is the most comprehensive biography and academic resource on Lewis. On pages 4–18, Buick provides additional detail on Lewis's early life prior to her move to Rome.

12. Buick, *Child of the Fire*, 27.

13. "Memorials: Edmonia Lewis," *Christian Register*, October 23, 1869, 2, quoted in Naurice Frank Woods Jr., *Race and Racism in Nineteenth-Century Art: The Ascendency of Robert Duncanson, Edward Bannister, and Edmonia Lewis* (Jackson: University Press of Mississippi, 2021), 179.

14. Buick, *Child of the Fire*, 59. Buick observes that "in terms of gender ideals of the nineteenth century, woman belongs to the man who has the capacity to protect her."

15. Kathy Perkins, "The Genius of Meta Warrick Fuller," *Black American Literature Forum* 24, no. 1 (Spring 1990): 67, https://doi.org/10.2307/2904066.

16. Renée Ater, "Race, Gender, and Nation: Rethinking the Sculpture of Meta Warrick Fuller" (PhD diss., University of Maryland, 2000). Ater's thesis and her book, *Remaking Race and History: The Sculpture of Meta Warrick Fuller* (Berkeley:

University of California Press, 2011), are the most comprehensive resources on the life and work of Meta Vaux Warrick Fuller and were a primary source for biographic information on Fuller.

17. "The Youngest and Best Sculptress of the Race Wins Fame and Honor in the Arts Centre of Paris—A Product of This City," *Philadelphia Tribune*, October 25, 1902, quoted in Judith Kerr, "God Given Work: The Life and Times of Meta Vaux Warrick Fuller, 1877–1968" (PhD diss., University of Massachusetts, 1986), 141.

18. W. Fitzhugh Brundage, "Meta Warrick's 1907 'Negro Tableaux' and (Re) Presenting African American Historical Memory," *Journal of American History* 89, no. 4 (March 2003): 1397. Brundage writes that in the fourteen dioramas that Fuller created, she "used more than 130 painted plaster figures, model landscapes, and backgrounds to give viewers a chronological survey of the African American experience." Scenes ranged from a tableaux of a fugitive slave to a depiction of the home life of "the modern, successfully educated, and progressive Negro." All the dioramas were destroyed by fire in 1910, and all that remains are some archival photos of the original tableaux.

19. Meta Vaux Warrick Fuller, interview by Sylvia Dannett, April 9–10, 1964, quoted in Kerr, "God Given Work," 181. Dannett interviewed Fuller in April 1964 for her book *Profiles of Negro Womanhood, Vol II* (Yonkers, NY: Educational Heritage, 1966). The original Sylvia G. L. Dannett Papers (SDP) are located in Heritage Hall, Livingstone College, Salisbury, NC.

20. Ray Cavanaugh, "On World Alzheimer's Day, the Black Doctor Who Helped Decode the Disease," *Washington Post*, September 21, 2021. Solomon Carter Fuller (1872–1953) was selected in 1904 to work with Alois Alzheimer and subsequently conducted groundbreaking research on dementia, which is now called Alzheimer's disease. Fuller's work on Alzheimer's would be his lifelong passion, and he became recognized internationally as an expert in this field, publishing the first comprehensive review of this disease and teaching at Boston University. However, Fuller could not escape the racial inequities of being an African American; he was paid less than his white counterparts and was never even given a full professorship. He retired from Boston University in 1953 when a junior white colleague was promoted over him.

21. Fuller to Murray, February 17, 1915, FHM Murray Papers.

22. Perkins, "The Genius of Meta," 69. Perkins discusses Fuller's sculpture studio, which Fuller "built secretly in 1920 with funds inherited from her grandfather Henry Jones. Upon learning of her studio, her husband Solomon became furious not only because his wife had concealed the project from him but because she had not asked his permission."

23. David Artis, "Pictures of Progress," *Black Scholar* 22, no. 4 (1992): 45. Artis's complete text is as follows: "Fuller, Hayden, and the others developed particular fashions of illuminating one or more of the vital aspect[s] of the Renaissance ideology: celebration of African heritage, employment of the tradition of black folklore, respectful treatment of every day black life."

24. In *Emancipation*, the weeping woman is an allegorical representation of Humanity, or the human race; her tears are for the pain humankind will inflict upon the Black race. "Allegorical art" is defined by the Tate Museum as "when the subject of the artwork, or the various elements that form the composition, is used to symbolize a deeper moral or spiritual meaning such as life, death, love, virtue, justice." Tate Museum, s.v. "Allegory," accessed September 21, 2021, https://www.tate.org.uk/art/art-terms/a/allegory.

25. Murray, *Emancipation and the Freed*, 57–58.

26. Review of *Emancipation*, *Framingham Evening News*, n.d., quoted in Murray, *Emancipation and the Freed*, 57.

27. Gay, *Art and Act*, 12–14.

28. Kirk Savage, *Standing Soldiers, Kneeling Slaves: Race, War, and Monument in Nineteenth-Century America* (Princeton, NJ: Princeton University Press), 1999, 12. Savage notes that "before 1860, there are no known images whatsoever of African Americans, slave or free, in marble or bronze."

29. For greater detail on nineteenth-century neoclassical art and Black iconography, see Charmaine Nelson, "White Marble, Black Bodies and the Fear of the Invisible Negro: Signifying Blackness in Mid-Nineteenth-Century Neoclassical Sculpture," *Canadian Art Review* 27 (2000): 87–101, and Melissa Dabakis, "Ain't I a Woman? Anne Whitney, Edmonia Lewis, and the Iconography of Emancipation," in *Seeing High and Low: A Critical Overview of Visual Cultural Studies*, ed. Patricia Johnson (Berkeley: University of California Press, 2006), 84–101.

30. Melissa Dabakis, *A Sisterhood of Sculptors: American Artists in Nineteenth-Century Rome* (University Park: Penn State University Press, 2014), 165.

31. Benjamin Quarles, "A Sidelight on Edmonia Lewis," *The Journal of Negro History* 30.1 (1945), 82–84, https://www.journals.uchicago.edu/doi/abs/10.2307/2715271.

32. Dabakis, *A Sisterhood of Sculptors*, 173.

33. Sharon F. Patton, *African-American Art*, Oxford History of Art (Oxford: Oxford University Press, 1998), 106.

34. Henry Louis Gates Jr., *Stony the Road: Reconstruction, White Supremacy, and Jim Crow* (New York: Penguin Press, 2019), 194.

35. Brundage, "Warrick's 1907 'Negro Tableaux,'" 1400.

36. Welter, "Cult of True Womanhood," 152.

37. Paula Giddings, *When and Where I Enter: The Impact of Black Women on Race and Sex in America* (New York: HarperCollins, 2006), 62.

38. Welter, "Cult of True Womanhood," 174.

39. Brundage, "Warrick's 1907 'Negro Tableaux,'" 1396.

40. Gay, *Art and Act*, 14.

41. Edmonia Lewis to Mrs. Chapman, February 5, 1867, Internet Archives, accessed October 13, 2022, https://archive.org. Although Lewis intended *Forever Free* to be given to Rev. Garrison, the statue was ultimately presented to Rev. Leonard Grimes in recognition of his work in abolishing slavery in this country. Details can be found in Buick, *Child of Fire*, 52, and Woods, *Race and Racism*, 178–79.

42. Edmonia Lewis, interview by Lydia Maria Child, *The Liberator*, February 19, 1864, quoted in Buick, *Child of the Fire*, 13.

43. "Edmonia Lewis," *West Chester (PA) Morning Republican*, May 1, 1871, Nineteenth Century US Newspapers, https://www.gale.com/c/nineteenth-century-us -newspapers.

44. Fuller's letters to Freeman Murray convey her passions for social and political issues and document her work with the Equal Suffrage Organization, the Red Cross, and St. Andrews Episcopal Church, as well as community-based theatre productions.

45. Fuller to Murray, January 6, 1915, FHM Murray Papers.

46. Fuller to Murray, July 9, 1915, FHM Murray Papers.

47. Jacqueline Francis and Stephen G. Hall, "W. E. B. Du Bois in Paris: The Exhibition That Shattered Myths About Black America," *Lit Hub*, https://lithub .com/w-e-b-du-bois-in-paris-the-exhibition-that-shattered-myths-about-black -america/.

48. Deborah Willis, "The Sociologist's Eye: W. E. B. Du Bois and the Paris Exposition," in *A Small Nation of People: W. E. B. Du Bois and African-American Portraits of Progress*, 77, https://archive.org/details/smallnationofpeooooounse/ page/78/mode/2up.

Chapter 2: ". . . thenceforward, and forever free"

1. The Emancipation Proclamation states, "That on the first day of January, in the year of our Lord one thousand eight hundred and sixty-three, all persons held as slaves within any State or designated part of a State, the people whereof shall then be in rebellion against the United States, shall be then, thenceforward, and forever free."

2. Eric Foner, *Reconstruction: America's Unfinished Revolution 1863–1877* (New York: Perennial Classics, 2002), 5. Foner attributes the origin of the term "contrabands of war" to General Benjamin Butler, who successfully applied the legal status of "contraband" to fugitive slaves, providing the Union Army with justification for emancipating slaves and employing them as laborers. On pages 7–10, Foner describes the two political events that enabled Blacks to enlist in the Union Army: the Second Confiscation and Militia Act, passed on July 17, 1862, and the Emancipation Proclamation, signed by President Lincoln on January 1, 1863. For statistics on Black enlistment rates, see Elsie Freeman, Wynell Burroughs Schamel, and Jean West, "The Fight for Equal Rights: A Recruiting Poster for Black Soldiers in the Civil War," *Social Education* 56, no. 2 (February 1992): 118–20. The number of "contrabands" is cited from Leslie A. Schwalm, "Surviving Wartime Emancipation: African Americans and the Cost of Civil War," *Journal of Law, Medicine and Ethics* 39, no. 21 (Spring 2011): 21–27.

3. Charles L. Perdue Jr. and Thomas E. Barden, *Weevils in the Wheat: Interviews with Virginia Ex-Slaves* (Charlottesville: University of Virginia Press, 1976), 212. Oral interview of Susie Melton, undated.

4. Yohuru Williams, "Why Frederick Douglass Matters," History.com, June 1, 2020, https://www.history.com/news/frederick-douglass-bicentennial.

5. Du Bois, *Black Reconstruction in America 1860–1880* (New York: Free Press, 1935), 124.

6. The Freedmen's Bureau Online, accessed June 9, 2022, http://www.freed mensbureau.com. The definition of the Freedmen's Bureau is given as follows: "The Freedmen's Bureau, formally known as the Bureau of Refugees, Freed-men and Abandoned Lands, was established in 1865 by Congress to help newly freed blacks, as well as poor Southern whites, deal with the aftereffects of the Civil War. The Bureau supervised all relief and educational activities relating to refugees and freedmen, including issuing rations, clothing, and medicine."

7. Carl Schurz, "General Ideas and Schemes of Whites Concerning the Freed-men," in *Report on the Condition of the South* (1865; Project Gutenberg, 2005), https://www.gutenberg.org/cache/epub/8872/pg8872.html.

8. "Newspaper Account of a Meeting between Black Religious Leaders and Union Military Authorities," *New York-Daily Tribune*, February 13, 1865, Freedmen and Southern Society Project, http://www.freedmen.umd.edu/savmtg.htm. On January 12, 1865, Rev. Garrison Frazier was the spokesperson for the group of African American religious leaders who held "an interview with Edwin M. Stanton, Secretary of War, and Major-Gen. Sherman, to have a conference upon matters relating to the freedmen of the State of Georgia."

9. Foner, *Reconstruction*, 70–71. Foner attributes the origin of the phrase "forty acres and a mule" to General Sherman's Special Field Order 15, issued in 1865. Sherman's order established an exclusive settlement area for Blacks outside of Charleston, South Carolina, with each family receiving forty acres and the loan of a mule. The order was short-lived; on April 14, 1865, the land grants were revoked, and all land was returned to the former Confederate landowners. The expectation had been set, and "forty acres and a mule" became a rallying cry for Black justice.

10. F. L. Frost to "My der Mamma" [Mrs. Edward Frost], December 28, 1865, Alston-Pringle-Frost Papers, South Carolina Historical Society, quoted in Leslie A. Schwalm, *A Hard Fight for We: Women's Transition from Slavery to Freedom in South Carolina* (Urbana: University of Illinois Press, 1997), 160–61.

11. Leon Litwack, *Been in the Storm So Long: The Aftermath of Slavery* (New York: Knopf, 1979), 366. Litwack explains that although Black codes varied from state to state, they all had the same underlying principles: "While the codes defined the freedman's civil and legal rights, permitting him to marry, hold and sell property, and sue and be sued, the key provisions were those which defined him as an agricultural laborer, barred from any alternative occupations, and compelled him to work."

12. Arthur Greene, interview by Susie Byrd, 1939, quoted in Perdue and Barden, *Weevils in the Wheat*, 126.

13. Litwack, *Been in the Storm*, 448.

14. Nelly Loyd, interview by G. L. Summer, November 16, 1937, transcript, *Slave Narratives: A Folk History of Slavery in the United States from Interviews with Former Slaves*, Library of Congress, Washington, DC, https://www.loc.gov/resource/mesn.143/?st=gallery.

15. Michael Hatt, "'Making a Man of Him': Masculinity and the Black Body in Mid-Nineteenth-Century American Sculpture," *The Oxford Art Journal* 15, no. 1 (1992): 29.

16. Murray, *Emancipation and the Freed*, 56.

17. James Oliver Horton, "Freedom's Yoke: Gender Conventions Among Antebellum Free Blacks," *Feminist Studies* 12, no. 1 (Spring 1986): 70.

18. Walter Wilcox, "The Negro Population," in *Negroes in the United States* (Bureau of the Census, 1904): 11–68, https://www2.census.gov/prod2/decennial/documents/03322287no8ch1.pdf.

19. Wilcox, "The Negro Population," 54.

20. Anna Julia Cooper, *A Voice from the South* (New York: Oxford University Press, 1988), 1439, https://books.google.com/books/about/A_Voice_From_the_South.html?id=E9fct-Xfo-YC.

21. "Black Families Severed by Slavery," *Equal Justice Initiative*, January 29, 2018, https://eji.org/news/history-racial-injustice-black-families-severed-by-slavery/.

22. Ari Shapiro, "After Slavery, Searching for Loved Ones in Wanted Ads," *Code Switch*, February 22, 2017, https://www.npr.org/sections/codeswitch/2017/02/22/516651689/after-slavery-searching-for-loved-ones-in-wanted-ads.

23. Benjamin Griffith Brawley, *The Negro in Literature and Art in the United States* (New York: Duffield, 1930), 121–22.

24. Du Bois, *Black Reconstruction in America*, 123.

25. Arthur Greene, interview by Susie Byrd, 1939, quoted in Perdue and Barden, *Weevils in the Wheat*, 126.

26. Heather Andrea Williams, "'Clothing Themselves in Intelligence': The Freedpeople, Schooling, and Northern Teachers, 1861–1871," *Journal of African American History* 87, no. 4 (Fall 2002): 376.

27. American Freedman's Union Commission, *The Results of Emancipation in the United States of America* (New York: American Freedman's Union Commission, 1867), https://www.loc.gov/item/12014697.

28. Du Bois, *Black Reconstruction in America*, 226.

29. W. E. B. Du Bois, "The Jubilee of Freedom" [ca. 1913], MS 312, W. E. B. Du Bois Papers, Special Collections and University Archives, University of Massachusetts Amherst Libraries, https://credo.library.umass.edu/view/full/mums312-b212-i028.

30. Williams, "'Clothing Themselves in Intelligence,'" 379.

31. Foner, *Reconstruction*, 257–58.

32. *Reconstruction: America after the Civil War*, directed by Julia Marchesi (PBS, 2019).

33. Hamilton W. Pierson, *A Letter to Hon. Charles Sumner, with 'Statements' of Outrages upon Freedmen in Georgia, and an Account of His Expulsion from Andersonville, Ga., by the Ku-Klux Klan* (Washington, DC: Chronicle Print, 1870), https://www.loc.gov/item/12007856. Foner defines the Ku Klux Klan, also known as the KKK, as "a loosely formed hate group formed after the Civil War" and "a military force serving the interests of the Democratic party, the planter class, and all those who desired the restoration of white supremacy." Foner, *Reconstruction*, 425.

34. Foner, *Reconstruction*, 588. Foner defines the Southern Redeemers as "a political coalition after Reconstruction, . . . the Southern wing of the Bourbon Democrats, the conservative, pro-business faction in the Democratic Party. They sought to regain their political power and enforce white supremacy."

35. Frederick Douglass, "The Color Question," July 5, 1875, MSS 11879, box 23, reel 15, Frederick Douglass Papers: Speech, Article, and Book File, 1846–1894, Manuscript Division, Library of Congress, Washington, DC, https://www.loc.gov/item/mss11879004l5/, and John Muller, *Frederick Douglass: The Lion of Anacostia* (Charleston, SC: History Press, 2012), 98.

36. "Plessy v. Ferguson," History.com, February 21, 2020, https://www.history.com/topics/black-history/plessy-v-ferguson. This article states that "*Plessy v. Ferguson* was a landmark 1896 U.S. Supreme Court decision that upheld the constitutionality of racial segregation under the 'separate but equal' doctrine. This decision legalized the restrictive Jim Crow legislation and the separation of public accommodations into 'colored' and white."

37. Du Bois, *Black Reconstruction in America*, 703.

38. Manning Marable, "The Politics of Black Land Tenure: 1877–1915," *Agricultural History* 53, no. 1 (January 1979): 142.

39. Du Bois, "The Jubilee of Freedom," 1–2.

40. Du Bois, "The Jubilee of Freedom," 1–2.

41. Gates, *Stony the Road*, 187.

42. Mabel Wilson, *Negro Building: Black Americans in the World of Fairs and Museums* (Berkeley: University of California Press, 2012), 9. https://doi.org/10.1525/9780520952492.

43. Gates, *Stony the Road*, 190.

44. Wilson, *Negro Building*, 7.

45. Wilson, *Negro Building*, 7.

46. Du Bois, "The Jubilee of Freedom," 1–2.

47. "National Emancipation Exposition," *Washington (DC) Bee*, October 25, 1913, 8.

48. "Three Expositions," *The Crisis: A Record of the Darker Races* 6, no. 6 (October 1, 1913): 297, NewsBank. This article details the planned programs for the National Emancipation Exposition, writing that "the exposition will be divided into fifteen different parts. . . . These departments will be illustrated by maps and

charts, models of buildings, statues, model rooms, photographs, gardens and flowers, artisans at work, a moving-picture show with special films, and, above all, a pageant illustrating the history of the Negro Race."

49. Ater, "Race, Gender, and Nation," 73. Ater notes that Fuller created a white plaster version of *Emancipation* for the exposition, intending to have it cast in bronze later. Although the subjects were not black in color, they were Black in their physicality and facial features.

50. Three Expositions," *The Crisis*, 297.

51. Du Bois, *Black Reconstruction in America*, 708.

Chapter 3: "Lifting as They Climb"

1. Zora Neale Hurston, *Their Eyes Were Watching God* (1937; repr., New York: First Harper Perennial Modern Classics, 2006), 44. Page references are to the 2006 edition.

2. Perdue and Barden, *Weevils in the Wheat*, 292–96.

3. Mary Church Terrell, "The Progress of Colored Women (1898)," in *The Portable Nineteenth-Century African American Women Writers*, ed. Hollis Robbins and Henry Louis Gates Jr. (London: Penguin, 2017), 440.

4. "Seeking Equality Abroad: Why Miss Edmonia Lewis, the Colored Sculptor, Returns to Rome—Her Early Life and Struggles," *New York Times*, December 29, 1878, 5, quoted in Buick, *Child of the Fire*, 18.

5. Fuller to Murray, February 8, 1915, FHM Murray Papers.

6. Alexander Crummell, *The Black Woman of the South: Her Neglects and Her Needs* (Cincinnati, OH: Woman's Home Missionary Society of the Methodist Episcopal Church, 1883), 5.

7. Schwalm, *A Hard Fight*, 149–212.

8. Victoria Perry, interview by G. L. Summer, November 16, 1937, transcript, *Slave Narratives: A Folk History of Slavery in the United States from Interviews with Former Slaves*, Library of Congress, Washington, DC, https://www.loc.gov/resource/mesn.143/?st=gallery.

9. J. W. Alvord, *Letters from the South, Relating to the Condition of Freedmen, Addressed to Major General O. O. Howard, Commissioner, Bureau R. F., and A. L.* (Washington, DC: Howard University Press, 1870), http://www.loc.gov/resource/rbaapc.00700.

10. Litwack, *Been in the Storm*, 255.

11. Mary Farmer-Kaiser, *Freedwomen and the Freedmen's Bureau: Race, Gender and Public Policy in the Age of Emancipation* (New York: Fordham University Press, 2010), 34.

12. Clinton Fisk, *Plain Counsels for Freedmen: In Sixteen Brief Lectures* (Boston: American Tract Society, 1866), 33–34.

13. Farmer-Kaiser, *Freedwomen*, 39.

14. Claudia Goldin, "Female Labor Force Participation: The Origin of Black and White Differences, 1870–1880," *Journal of Economic History* 37, no. 1 (March 1977): 95. In 1870, roughly 50 percent of all Black women worked outside the home, compared to fewer than 17 percent of all white women. Goldin explains that "in order to compute the labor force participation of women in 1870 and 1880 the manuscripts of the United States Population Census have been sampled and to enable an analysis of these data to be made, economic and demographic variables have been coded. Although the compilers of the 1870 and 1880 Federal Population Censuses collected data on occupation and family structure by race and by sex, they did not analyze this information."

15. Schwalm, *A Hard Fight*, 178.

16. Farmer-Kaiser, *Freedwomen*, 158.

17. Hannah Rosen, "In the Moment of Violence: Writing the History of Postemancipation Terror," in *Beyond Freedom*, ed. David W. Blight and Jim Downs (Athens: University of Georgia Press, 2017), 146.

18. "A Rara Avis," *San Francisco Daily Dramatic Chronicle (1865–1868)*, May 25, 1866, 4.

19. "Am I Not a Woman and a Sister?," *History Matters*, accessed July 1, 2022, http://historymatters.gmu.edu/d/6726/. This article states the following: "African-American women held as slaves were particularly vulnerable to abuse at the hands of their white owners. This engraving appeared in abolitionist George Bourne's *Slavery Illustrated in Its Effects upon Women*, published in 1837. It highlighted the connections between the anti-slavery and women's rights movements, as some women abolitionists, such as Sarah and Angelina Grimke, used the anti-slavery cause to address their own plight as women."

20. Dabakis, "Ain't I a Woman?," 97. Dabakis defines the contradictory identities of Black womanhood as follows: "Lewis imagined an African American identity for her female figure as consonant with the cult of true womanhood, yet this identity maintained the strength and determination specific to freed black women," 98.

21. Dabakis, "Ain't I a Woman?," 95.

22. Buick, *Child of the Fire*, 67.

23. Farmer-Kaiser, *Freedwomen*, 13.

24. Litwack, *Been in the Storm*, 246.

25. Kerr, "God Given Work," 25.

26. Meta Vaux Warrick Fuller, interview by Sylvia Dannett, April 7–8, 1964, transcript, p. 36, Sylvia Dannett Papers, quoted in Ater, "Race, Gender, and Nation", 58.

27. Kerr, "God Given Work," 186.

28. Mary Church Terrell, "Being a Colored Woman in the United States," n.d., p. 14, MSS 42549, box 32, reel 23, Mary Church Terrell Papers: Speeches and Writings, 1866–1953, Manuscript Division, Library of Congress, Washington, DC, https://www.loc.gov/resource/mss42549.mss42549-023_00123_00152/?sp=30.

29. Giddings, *When and Where*, 81.

30. Anna Julia Cooper, "Womanhood a Vital Element in the Regeneration and Progress of a Race," in *The Portable Nineteenth-Century African American Women Writers*, ed. Hollis Robbins and Henry Louis Gates Jr. (New York: Penguin House, 2017), 427.

31. Charles Reagan Wilson, "Racial Uplift," in *The New Encyclopedia of Southern Culture*, ed. Thomas Holt, Laurie B. Green, Charles Reagan Wilson (Chapel Hill: University of North Carolina Press, 2013), 24:128, http://www.jstor.org/stable/10.5149/9781469607245. Wilson defines racial uplift as "a belief that [Black middle-class] advocates . . . should nurture black respectability as a way toward social advancement. This outlook called for black elites to assume responsibility for working with the black masses to encourage them to follow middle-class values of temperance, hard work, thrift, perseverance, and Victorian-era sexual self-restraint."

32. "Remembering Mary Turner," The Mary Turner Project, http://www.maryturner.org (site discontinued), provides the following background information: "In May, 1918 Mary Turner, 8 months pregnant at the time and whose husband had been killed in this 'lynching rampage' publicly objected to her husband's murder. She also had the audacity to threaten to swear out warrants for those responsible. Those 'unwise remarks,' as the area papers put it, enraged locals. To punish her, at Folsom's Bridge the mob tied Mary Turner by her ankles, hung her upside down from a tree, poured gasoline on her and burned off her clothes. One member of the mob then cut her stomach open, and her unborn child dropped to the ground where it was reportedly stomped on and crushed by a member of the mob. Her body was then riddled with gunfire from the mob." Of note, Fuller's statue was a tribute to the 1917 Silent Parade by the National Association for the Advancement of Colored People (NAACP), conducted in protest of the lynching.

33. Julie Buckner Armstrong, "'The People . . . Took Exception to Her Remarks': Meta Warrick Fuller, Angelina Weld Grimke, and the Lynching of Mary Turner," *Mississippi Quarterly* 61, no. 1 (2008): 119.

34. Meta Vaux Warrick Fuller, interview by Sylvia Dannett, April 7–8, 1964, transcript, p. 36, Sylvia Dannett Papers, quoted in Ater, "Race, Gender, and Nation," 133.

35. Terrell, "Being a Colored Woman," Mary Church Terrell Papers.

36. Fuller to Murray, January 31, 1916, FHM Murray Papers.

37. Fuller to Murray, January 9, 1915, FHM Murray Papers.

38. Ater, "Race, Gender, and Nation," 79.

39. Murray, *Emancipation and the Freed*, 64.

40. Fuller to Murray, April 5, 1915, FHM Murray Papers.

41. Murray, *Emancipation and the Freed*, 65.

42. Meta Vaux Warrick Fuller, interview by Sylvia Dannett, April 7–8, 1964, transcript, p. 35, Sylvia Dannett Papers, quoted in Ater, "Race, Gender, and Nation," 198.

43. Romare Bearden and Harry Henderson, *A History of African American Artists: From 1792 to the Present* (New York: Pantheon, 1993), 66.

44. Meta Vaux Warrick Fuller, interview by Sylvia Dannett, April 7–8, 1964, transcript, p. 36, Sylvia Dannett Papers, quoted in Kerr, "God Given Work," 181.

45. "Edmonia Lewis," *The Revolution*, April 20, 1871; Accessible Archives, accessed October 13, 2022, https://www.accessible-archives.com.

46. Brawley, *The Negro in Literature*, 121–22.

47. Terrell, "Progress of Colored Women," 440.

Chapter 4: Never Forget

1. Savage, *Standing Soldiers, Kneeling Slaves*, 4.

2. Blight, *Beyond the Battlefield*, 96.

3. Savage, *Standing Soldiers, Kneeling Slaves*, 210.

4. Ron Eyerman, *Cultural Trauma: Slavery and the Formation of African American Identity* (Cambridge: Cambridge University Press, 2001), 5. Eyerman defines cultural trauma as "a dramatic loss of identity and meaning, a tear in the social fabric, affecting a group of people that has achieved some degree of cohesion."

5. Blight, *Beyond the Battlefield*, 120.

6. Blight, *Beyond the Battlefield*, 278.

7. Frederick Douglass, "Address Delivered on the Twenty-Sixth Anniversary of Abolition in the District of Columbia," April 1888, History Is a Weapon, https://www.historyisaweapon.com/defcon1/douglassfraud.html.

8. "Richmond Dispatch," *Richmond (VA) Daily Dispatch* 29, no. 186 (April 1866): 3, https://virginiachronicle.com.

9. Kathleen Clark, "Celebrating Freedom: Emancipation Day Celebrations and African American Memory in Early Reconstruction South," in *Where These Memories Grow: History, Memory, and Southern Identity*, ed. W. Fitzhugh Brundage (Chapel Hill: University of North Carolina Press, 2000), 116.

10. Savage, *Standing Soldiers, Kneeling Slaves*, 210.

11. Mitch Landrieu, *In the Shadow of Statues: A White Southerner Confronts History* (New York: Viking, 2018), 40. The eighty-foot statue of General Robert E. Lee was taken down in 2017.

12. Murray, *Emancipation and the Freed*, 135–36.

13. Albert Boime, *The Art of Exclusion: Representing Blacks in the Nineteenth Century* (Washington, DC: Smithsonian Institution Press, 1990), 171.

14. Kendi, *Stamped from the Beginning*, 306. Kendi writes that the silent film *Birth of a Nation* "depicted Reconstruction as an era of corrupt Black supremacists petrifying innocent whites." Kendi also notes that between February 1915 and January 1916 more than three million people in New York City had viewed the film.

15. Du Bois, *Black Reconstruction in America*, 725.

16. Du Bois, *Black Reconstruction in America*, 713.

17. Bennett Minton, "The Lies Our Textbooks Told My Generation of Virginians About Slavery," *Washington Post*, July 31, 2020, https://www.washingtonpost.com/outlook/slavery-history-virginia-textbook/2020/07/31/d8571eda-d1f0-11ea-8c55-61e7fa5e82ab_story.html.

18. James Baldwin, "The American Dream and the American Negro," *New York Times*, March 7, 1965, https://archive.nytimes.com/www.nytimes.com/books/98/03/29/specials/baldwin-dream.html.

19. Zinn Education Project, "Report: State by State, U.S. School Standards for Teaching Reconstruction are Failing Students," media release, January 2022, https://www.teachreconstructionreport.org/release.

20. Kendi, *Stamped from the Beginning*, 506–9.

21. John McWhorter, "Toward a Usable Black History," *City Journal*, Summer 2001, https://www.city-journal.org/html/toward-usable-black-history-12171.html.

22. Catherine Adams et al., "An Open Letter on the Need to Teach the Reconstruction Era," in *Erasing the Black Freedom Struggle: How State Standards Fail to Teach the Truth About Reconstruction*, by Ana Rosado, Gideon Cohn-Postar, and Mimi Eisen, accessed July 3, 2022, https://www.teachreconstructionreport.org/open-letter.

23. Katie Reilly, "Read President Obama's Speech at the Museum of African American History and Culture," *Time*, September 2016, https://time.com/4506800/barack-obama-african-american-history-museum-transcript.

24. Jules Prown, "The Truth of Material Culture: History or Fiction?," in *American Artifacts: Essays in Material Culture*, ed. Jules Prown and Kenneth Haltman (East Lansing: Michigan State University Press, 2000), 15.

25. "Emancipation Memorial," National Park Service (NPS), accessed June 19, 2022, https://www.nps.gov/places/000/emancipation-memorial.htm. The NPS web site explains that Thomas Ball "depicted a life-size figure of Abraham Lincoln, extending one hand over a kneeling African American man while holdig a copy of the Emancipation Proclamation in the other hand. The former slave is depicted as rising, with broken shackles on his wrists."

26. In 1967 James Porter, an artist, professor, and director of the Howard University art gallery, purchased the sculpture for Howard University.

27. Murray, *Emancipation and the Freed*, xiv.

28. Washington, "Made in America," 248.

29. Prown, "Truth of Material Culture," 26.

30. Isaac Chotiner, "Learning from the Failure of Reconstruction," *New Yorker*, January 13, 2021, https://www.newyorker.com/news/q-and-a/learning-from-the-failure-of-reconstruction.

31. Murray, *Emancipation and the Freed*, xix.

REFERENCES

Alvord, J. W. *Letters from the South, Relating to the Condition of Freedmen, Addressed to Major General O. O. Howard, Commissioner, Bureau R. F., and A. L.* Washington, DC: Howard University Press, 1870. http://www.loc.gov/resource/rbaapc.00700.

Armstrong, Julie B. "'The People . . . Took Exception to Her Remarks': Meta Warrick Fuller, Angelina Weld Grimke, and the Lynching of Mary Turner." *Mississippi Quarterly* 61, no. 1 (2008): 113–40.

Artis, David. "Pictures of Progress." *Black Scholar* 22, no. 4 (1992): 42–47. https://doi.org/10.1080/00064246.1992.11413058.

Ater, Renée. "Race, Gender, and Nation: Rethinking the Sculpture of Meta Warrick Fuller." PhD diss., University of Maryland, 2000.

Ater, Renée. *Remaking Race and History: The Sculpture of Meta Warrick Fuller.* Oakland: University of California Press, 2011.

Bearden, Romare, and Harry Henderson. *A History of African American Artists: From 1792 to the Present.* New York: Pantheon, 1993.

Blight, David W. *Beyond the Battlefield: Race, Memory, and the American Civil War.* Amherst: University of Massachusetts Press, 2002.

Boime, Albert. *The Art of Exclusion: Representing Blacks in the Nineteenth Century.* Washington, DC: Smithsonian Institution Press, 1990.

Brawley, Benjamin Griffith. *The Negro in Literature and Art in the United States.* New York: Duffield, 1930.

Brundage, W. Fitzhugh. "Introduction: No Deed but Memory." In *Where These Memories Grow: History, Memory, and Southern Identity*, edited by W. Fitzhugh Brundage, 1–28. Chapel Hill: University of North Carolina Press, 2000.

Brundage, W. Fitzhugh. "Meta Warrick's 1907 'Negro Tableaux' and (Re)Presenting African American Historical Memory." *Journal of American History* 89, no. 4 (March 2003): 1368–400. https://doi.org/10.2307/3092547.

Buick, Kirsten Pai. *Child of the Fire: Mary Edmonia Lewis and the Problem of Art History's Black and Indian Subject.* Durham, NC: Duke University Press, 2010.

Butcher, Margaret Just. *The Negro in American Culture.* New York: Alfred A. Knopf, 1966.

Clark, Kathleen. "Celebrating Freedom: Emancipation Day Celebrations and African American Memory in Early Reconstruction South." In *Where These*

Memories Grow: History, Memory, and Southern Identity, edited by W. Fitzhugh Brundage, 107–32. Chapel Hill: University of North Carolina Press, 2000.

Cooper, Anna Julia. *A Voice from the South*. New York: Oxford University Press, 1988. https://books.google.com/books/about/A_Voice_From_the_South .html?id=E9fct-Xf0-YC.

Cooper, Anna Julia. "Womanhood a Vital Element in the Regeneration and Progress of a Race." In *The Portable Nineteenth-Century African American Women Writers*, edited by Hollis Robbins and Henry Louis Gates Jr., 415–32. London: Penguin, 2017.

Crummell, Alexander. *The Black Woman of the South: Her Neglects and Her Needs*. Cincinnati, OH: Woman's Home Missionary Society of the Methodist Episcopal Church, 1883.

Dabakis, Melissa. "Ain't I a Woman? Anne Whitney, Edmonia Lewis, and the Iconography of Emancipation." In *Seeing High and Low: A Critical Overview of Visual Cultural Studies*, edited by Patricia Johnson, 84–101. Berkeley: University of California Press, 2006.

Dabakis, Melissa. *A Sisterhood of Sculptors: American Artists in Nineteenth-Century Rome*. University Park: Penn State University Press, 2014. Douglass, Frederick, and George L. Ruffin. *The Life and Times of Frederick Douglass*. Scituate, MA: Digital Scanning, 2001.

Du Bois, W. E. B. *Black Reconstruction in America 1860–1880*. New York: Free Press, 1935.

Du Bois, W. E. B. *The Souls of Black Folks*. New York: Dover Publications, 1994.

Eyerman, Ron. *Cultural Trauma: Slavery and the Formation of African American Identity*. Cambridge: Cambridge University Press, 2001.

Farmer-Kaiser, Mary. *Freedwomen and the Freedmen's Bureau: Race, Gender, and Public Policy in the Age of Emancipation*. New York: Fordham University Press, 2010.

Fisk, Clinton. *Plain Counsels for Freedmen: In Sixteen Brief Lectures*. Boston: American Tract Society, 1866.

Foner, Eric. *Reconstruction: America's Unfinished Revolution 1863–1877*. New York: Perennial Classics, 2002.

Frazier, Susan E. "Some Afro-American Women of Mark." In *The Portable Nineteenth-Century African American Women Writers*, edited by Hollis Robbins and Henry Louis Gates Jr., 586–604. New York: Penguin House, 2017.

Gay, Peter. *Art and Act: On Causes in History—Manet, Gropius, Mondrian*. New York: Harper and Row, 1976.

Giddings, Paula. *When and Where I Enter: The Impact of Black Women on Race and Sex in America*. New York: HarperCollins, 2006.

Goldin, Claudia. "Female Labor Force Participation: The Origin of Black and White Differences, 1870–1880." *Journal of Economic History* 37, no. 1 (March 1977): 87–108.

Hatt, Michael. "'Making a Man of Him': Masculinity and the Black Body in Mid-Nineteenth-Century American Sculpture." *The Oxford Art Journal* 15, no. 1 (1992): 21–35.

Henri, Florette. *Black Migration: Movement North 1900–1920, The Road from Myth to Man.* Garden City, NY: Anchor Press/Doubleday, 1976.

Horton, James Oliver. "Freedom's Yoke: Gender Conventions Among Antebellum Free Blacks." *Feminist Studies* 12, no. 1 (Spring 1986): 51–76. https://doi.org/10.2307/3177983.

Hurston, Zora Neale. *Their Eyes Were Watching God.* 1937. Reprint, New York: First Harper Perennial Modern Classics, 2006.

Kendi, Ibram X. *Stamped from the Beginning: The Definitive History of Racist Ideas in America.* New York: Bold Type Books, 2016.

Kerr, Judith. "God Given Work: The Life and Times of Meta Vaux Warrick Fuller, 1877–1968." PhD diss., University of Massachusetts, 1986.

Landrieu, Mitch. *In the Shadow of Statues: A White Southerner Confronts History.* New York: Viking, 2018.

Litwack, Leon. *Been in the Storm So Long: The Aftermath of Slavery.* New York: Knopf, 1979.

Marable, Manning. "The Politics of Black Land Tenure: 1877–1915." *Agricultural History* 53, no. 1 (January 1979): 142–52.

Marchesi, Julia, dir. *Reconstruction: America after the Civil War.* PBS, 2019.

Muller, John. *Frederick Douglass: The Lion of Anacostia.* Charleston, SC: History Press, 2012.

Murray, Freeman Henry Morris. *Emancipation and the Freed in American Sculpture: A Study in Interpretation.* Washington, DC: Murray Brothers, 1916.

Nelson, Charmaine. *The Color of Stone: Sculpting the Black Female Subject in Nineteenth-Century America.* Minneapolis: University of Minnesota Press, 2007.

Novo, Marla. "The Indian Maiden Visits San Jose: Rediscovering Edmonia Lewis." Master's thesis, San Jose State University, 1995.

Parfait, Claire, Hélène Le Dantec-Lowry, and Claire Bourhis-Mariotti. Introduction to *Writing History from the Margins: African Americans and the Quest for Freedom.* Edited by Claire Parfait, Hélène Le Dantec-Lowry, and Claire Bourhis-Mariotti, 1–10. New York: Routledge Press, 2017.

Patton, Sharon F. *African-American Art.* Oxford History of Art. Oxford: Oxford University Press, 1998.

Perdue, Charles L., Jr., and Thomas E. Barden. *Weevils in the Wheat: Interviews with Virginia Ex-Slaves.* Charlottesville: University of Virginia Press, 1976.

Perkins, Kathy. "The Genius of Meta Warrick Fuller." *Black American Literature Forum* 24, no. 1 (Spring 1990): 65–72. https://doi.org/10.2307/2904066.

Prown, Jules. "The Truth of Material Culture: History or Fiction?" In *American Artifacts: Essays in Material Culture*, edited by Jules Prown and Kenneth Haltman, 11–27. East Lansing: Michigan State University Press, 2000.

Reilly, Katie. "Read President Obama's Speech at the Museum of African American History and Culture." *Time*, September 2016. https://time.com/4506800/ barack-obama-african-american-history-museum-transcript.

"Remembering Mary Turner." The Mary Turner Project. http://www.maryturner .org (site discontinued).

Rosado, Ana, Gideon Cohn-Postar, and Mimi Eisen. *Erasing the Black Freedom Struggle: How State Standards Fail to Teach the Truth about Reconstruction.* Zinn Education Project, January 2022. https://www.teachreconstruction report.org.

Rosen, Hannah. "In the Moment of Violence: Writing the History of Postemancipation Terror." In *Beyond Freedom*, edited by David W. Blight and Jim Downs, 145–59. Athens: University of Georgia Press, 2017.

Savage, Kirk. *Standing Soldiers, Kneeling Slaves: Race, War, and Monument in Nineteenth-Century America.* Princeton, NJ: Princeton University Press, 1999.

Schurz, Carl. *Report on the Condition of the South.* 1865. Project Gutenberg, 2003.

Schwalm, Leslie A. *A Hard Fight for We: Women's Transition from Slavery to Freedom in South Carolina.* Urbana: University of Illinois Press, 1997.

Terrell, Mary Church. "Being a Colored Woman in the United States," n.d. Mary Church Terrell Papers. Speeches and Writings, 1866–1953. Manuscript Division. Library of Congress, Washington, DC. https://www.loc.gov/item/ mss425490555/.

Terrell, Mary Church. "The Progress of Colored Women (1898)." In *The Portable Nineteenth-Century African American Women Writers*, edited by Hollis Robbins and Henry Louis Gates Jr., 437–40. London: Penguin, 2017.

Washington, Tiffany. "Made in America: A Critical Revisionism to Revive the Canon." In *American Art: Collecting and Connoisseurship*, edited by Stephen M. Sessler, 242–49. London: Merrell Publisher, 2020.

Welter, Barbara. "The Cult of True Womanhood: 1820–1860." *American Quarterly* 18, no. 2 (Summer 1966): 151–74. https://doi.org/10.2307/2711179.

Wilcox, Walter. "The Negro Population." In *Negroes in the United States*, 11–68. Bureau of the Census, 1904.https://www2.census.gov/prod2/decennial/ documents/03322287n08ch1.pdf.

Williams, Fannie Barrier. "The Intellectual Progress of the Colored Woman of the United States Since the Emancipation Proclamation." In *The Portable Nineteenth-Century African American Women Writers*, edited by Hollis Robbins and Henry Louis Gates Jr., 394–405. London: Penguin, 2017.

Williams, Heather Andrea. "'Clothing Themselves in Intelligence': The Freedpeople, Schooling, and Northern Teachers, 1861–1871." *Journal of African American History* 87, no. 4 (Fall 2002): 372–89. https://doi.org/10.2307/1562471.

Williams, Yohuru. "Why Frederick Douglass Matters." History.com. Accessed June 1, 2020. https://www.history.com/news/frederick-douglass-bicentennial.

Willis, Deborah. "The Sociologist's Eye: W. E. B. Du Bois and the Paris Exposition." In *A Small Nation of People: W. E. B. Du Bois and African-American Portraits of*

Progress, 51–78. Washington, DC: Library of Congress, 2003. https://archive
.org/details/smallnationofpeoooooounse/page/n7/mode/1up.

Wilson, Mabel. *Negro Building: Black Americans in the World of Fairs and Museums.*
Berkeley: University of California Press, 2012.

Woods, Naurice Frank, Jr. *Race and Racism in Nineteenth-Century Art: The
Ascendency of Robert Duncanson, Edward Bannister, and Edmonia Lewis.*
Jackson: University Press of Mississippi, 2021.

INDEX

ABOUT THE AUTHOR

© Amanda Miles

Lee Ann Timreck is an independent researcher in the area of nineteenth-century African American history and material culture. She comes to the field of historical research after a career in business and serving as an officer in the United States Navy. Since completion in 2016 of George Mason University's Graduate Certificate Program in Folklore Studies, Lee Ann has deepened her knowledge of African American culture through graduate-level workshops and classes as well as presentations of research papers on the sculpture of African American artists Edmonia Lewis and Meta Warrick Fuller at professional conferences. She also conducted genealogical research and wrote publication-ready biographies for the historic African American Evergreen Cemetery in Richmond, Virginia.

Most recently, Lee Ann coauthored a chapter on the material culture of Richmond, Virginia, for an upcoming book entitled *Claims on the City: Alternative Understandings of the Urban*. This research explores how material culture was used to shape, and reshape, Richmond's racialized public landscape. When not busy researching or writing, Lee Ann enjoys travelling beyond the Richmond area to explore historical sites and museums around the world.